Anyone *Can* Draw

Anyone *Can* Draw

BARRINGTON BARBER

ARCTURUS

ARCTURUS

This edition published in 2014 by Arcturus Publishing Limited
26/27 Bickels Yard, 151–153 Bermondsey Street,
London SE1 3HA

ISBN: 978-1-84837-851-3
AD001721UK

Printed in China

CONTENTS

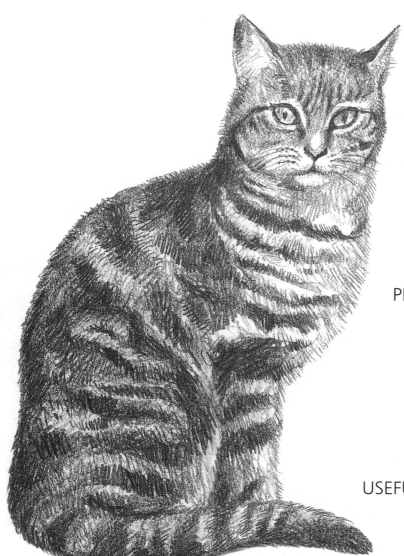

INTRODUCTION

It's not uncommon to hear people saying they would like to try their hand at art, adding, 'But I can't draw,' as if this were an immutable fact that rules them out from the start. Yet being able to draw isn't a rare and special quality. It does help if you have some innate talent, of course, but that isn't the main thing; in my long career as an art teacher I've often seen students with talent but not much will to work overtaken by much less naturally gifted students who were prepared to put in the groundwork and persevere. I've taught people from five years of age to 70 and have never come across anyone I couldn't teach to draw adequately if they really wanted to learn. So the first step is to feel confident that it's only a matter of how much work you are prepared to put into drawing that decides how well you will do, and that confidence will carry you through the small failures that occur whenever you try to learn a new skill.

This book follows a particular plan that has been designed to make the learning process easier for you. It begins by describing the most useful mediums for a beginner before moving on to the basics of line drawing, which is the simplest and most obvious method of drawing. Once you have gained some proficiency with that you will then tackle the use of tone and texture in order to flesh out your line drawings and make them look three-dimensional.

There's also a section on observation, which is the most important thing for an artist to practise; after all, you can't draw something accurately if you haven't really absorbed what it looks like in life. Accuracy in drawing the human figure is particularly important, because our familiarity with it means that mistakes in proportion are easily spotted. From this book you'll learn the classic proportions, so that if you do need to diverge from them to show an individual's particular characteristics you will be able to do so convincingly – many of us, let's face it, don't fit the classical norm. You'll also find a section on perspective that will help you to assess how to draw larger objects such as buildings without being too intimidated by the size and complexity of their structure.

Next, the composition of your picture is a useful thing to consider, although you may not want to think about this until you've been drawing for a while. However, to make your drawings work on a formal scale some understanding of how to compose a picture will enhance your artistic skill.

Finally, we'll look at some useful practices that all artists need to know in order to improve their ability. Learning to draw on the move, for instance, enables an artist to act on impulse and forces them to respond creatively to different situations. The great thing about drawing is that there's always another skill or sensitivity that you can add to your repertoire as an artist, and that's one of the things that keep artists working happily until their later years.

SUBJECT MATTER

In this book we'll look at all types of subject matter as you build up your skills. The easiest things to draw are simple everyday and still-life objects because you can arrange them as you like. Some more complex objects, such as musical instruments, are next in line of difficulty; after that come plants and, when you have mastered those, the whole landscape, where you have to cope with the light constantly changing and every breath of wind moving the vegetation and the clouds.

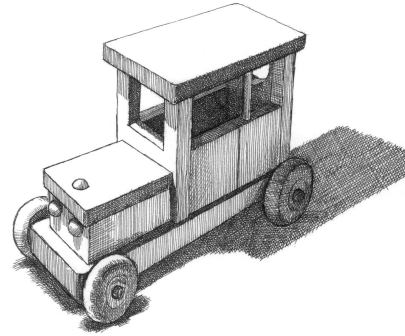

Animals are tricky to draw because they rarely keep still and generally have no inclination to do what you want. You'll often have to take photographs to work from in order to become more familiar with their shapes. When it comes to humans, for a portrait drawing you do have the advantage that the model probably wants to be drawn well and will pose for you – but we pick up many subtle distinctions in the human face, and if you miss them out it reduces the likeness of the portrait. It takes a while to achieve portraits that are convincing, showing not only the features realistically but also the person's character.

Probably the hardest subject matter for drawing is the human body as a whole. It's so complex that I believe even the most accomplished artists never achieve perfection in their works, so don't worry too much if your first attempts aren't great works of art. Drawing groups of figures is even more complex, but the challenges are very satisfying as well – and as soon as you have a little success you'll begin to see why artists find it impossible to stop drawing.

● THE BASICS

When you start to draw you need to know a few basics about how to handle your equipment and draw to size. Later you will begin to develop a personal style of working with which you feel comfortable.

HOLDING A PENCIL

You may think advice on how to hold a pencil seems rather unnecessary, but I assure you that an artist must learn how to handle the instruments of drawing properly in order to get the best results. You don't have to grasp the pencil in a vice-like grip, which it's easy to do without being aware of it if you're feeling a bit tense about tackling something difficult. Hold it loosely, so that you can manoeuvre it easily. Then practise different ways of handling it, as shown.

Hold your pencil as you would a stick, with your thumb on top, and see how well you can control your strokes. Don't grip it tightly. This method is ideal for drawing at an easel with the drawing board upright.

Then hold the pencil as you might usually hold it for writing, but again without gripping it tightly. Keep altering the way that you hold the pencil until you feel comfortable with different methods.

THE ANGLE OF THE PAPER

When you draw with the paper flat on a table-top, it's very easy to make distorted drawings because of the angle at which you see the surface. Ideally you should have the surface of the paper at right angles to your eyeline, so that you are always looking at the drawing centre on, which will eradicate accidental distortion. Although most artists find the best method is to use an easel, this is not necessary – you can simply tilt the paper on a table so that you can comfortably look directly at the surface.

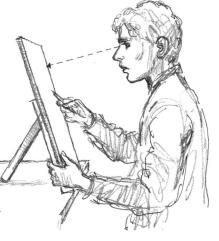

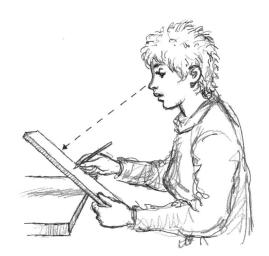

SIZING YOUR DRAWING

It's all too easy to fall into the habit of always drawing your subjects at the same size. This rather limits your ability to improve, as an artist should be able to draw at any size that is needed.

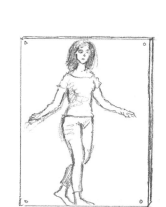

Making your drawing the same size that the subject appears to be from your viewpoint is a very good exercise. The drawing board and paper must be vertical for you to do this effectively, and you'll need a long pencil or a straight stick of some sort to measure with. Here we take the example of a human figure.

First place yourself so that you can see the model clearly, and extend your arm out until it is straight. This is essential because otherwise you will get varying measurements, which defeats the object. Then hold your pencil or stick upright so that the top is level with the top of your model's head and your thumb is at their feet. Mark this distance on your paper. If your model is too far away they will appear too small to be drawn properly, while if they are too close you will need a very long measuring device to cover the distance from head to feet. If need be, just move them to a reasonable distance, at which you will have a size that you can handle.

Draw everything to this size as carefully as you can; you'll probably be surprised by how small the drawing is, but if you get all the measurements right it will be very accurate. Don't forget to extend your arm to its full length each time you measure anything so that you get the proportionate measure each time.

Now try drawing on as large a sheet of paper as you can, perhaps A2 or A1 size. Draw the model with the top of the head touching the edge of the paper at

the top, and the feet right at the bottom of the paper. It doesn't matter what the pose is but ask your model to stretch out as much as possible, as long as they will be able to hold the pose. Now everything has to fit into this much larger format and you'll soon notice how easy it is to get the proportions wrong. Don't worry about this – look on it as a challenge, and just keep on correcting the drawing until you've made as good a job as you're able to in the time available.

The next time you draw anyone try the same trick but with a smaller format, such as a sketchbook, but working as large as is possible on the page. This practice of trying different sizes is important for you to extend your drawing abilities, even if you eventually settle on a preferred scale. Every now and again draw much larger than you usually do, just to test your ability.

CHAPTER 1
MARKS AND MATERIALS

When you first begin to draw it can be hard to know just what you should do to set off on the right track, so here we'll look at what drawing is about at the most basic level. Put simply, it's making marks on paper, and initially any marks will do.

Also in this chapter I'll show you the materials that you'll need to draw with, giving you some choices so that you'll have fun and explore different possibilities.

● PENCIL

The most common medium for drawing is pencil. Use B-grade pencils as they make a darker mark with less pressure required than the harder H pencils. Ideally you should have B, 2B, 4B, 6B and 8B as a range.

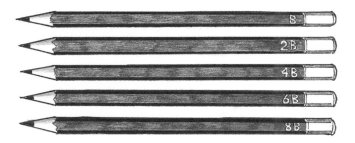

B-grade pencils are soft and wear down quite fast, so have several sharp pencils to hand. It will interrupt the flow of your work if you have to keep stopping to sharpen your pencil.

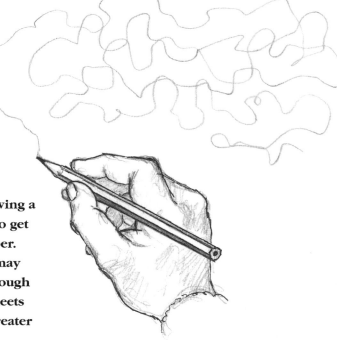

1. When you're ready, start drawing a wavy line in any direction just to get the feel of the pencil on the paper. This is more important than it may seem, because experiencing through your hand the way the pencil meets the paper gives your drawing greater sensitivity.

2. Scribble lines in all directions to make a patch of dark tone.

3. Then try a series of quickly made lines, all in the same direction and as close together as you can, to make a patch of tone.

4. Next, draw a number of lines in all directions, but shorter and spaced around to build up like a layer of twigs.

5. Draw a tonal patch with all the lines going in one direction in vertical strokes.

6. Next, draw horizontal strokes in the same manner.

7. Now combine horizontal and vertical lines with diagonals to produce a very dark patch of tone.

8. Draw a circle as accurately as you can. Although it's easy enough to imagine a perfect circle, drawing one takes careful work and yours will probably look like the one shown.

9. Now add a bit of tone to one side of your circle to give the impression of a three-dimensional sphere. Put a patch of tone underneath the sphere, to look like a shadow.

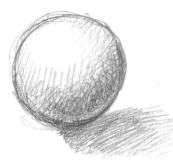

10. Now try a drawing of a group of leaves, keeping it simple and just aiming to express the feel of the plant's growth.

11. Similarly, draw a flower shape – don't try to be too exact at this stage.

Now we are taking a further step towards picture-making, because you are going to attempt a shape that resembles something that you might want to draw.

12. First draw a diamond shape that is flatter horizontally than vertically.

13. Then draw three vertical lines down from the left corner, the lower centre corner and the right corner. All the lines should be parallel to each other, with the outer two about the same length and the central one a little longer.

14. Now draw lines from the lower ends of the verticals, similar to the lower sides of the original diamond shape. This now looks like a cube shape.

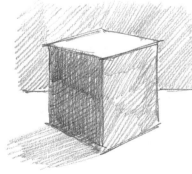

15. To increase the illusion of three dimensions, make a light tone across the background space to about halfway down the cube, then put tone over the two lower surfaces of the cube. Make the tone on one of the lower sides even darker. To finish off the illusion, draw a tone from the bottom of the darkest side of the cube across the surface that the cube is standing on. The final result looks like a box standing on a surface.

● PEN AND INK

To draw with pen and ink, the most obvious tool to go for is a graphic pen. These are available in several sizes, and you will need a 0.1, a 0.3 and a 0.8 to give you a fine line and two rather thicker lines. You can buy them in any stationery or art supplies shop. There's no variation in the line from these pens, so if this is what you want, use instead a push pen with a fine nib and a bottle of black India ink. If the pen nib is flexible enough you can vary the thickness of the line at will, by exerting or releasing a little more pressure on the pen. These pens are available from a good art shop or a specialist pen shop.

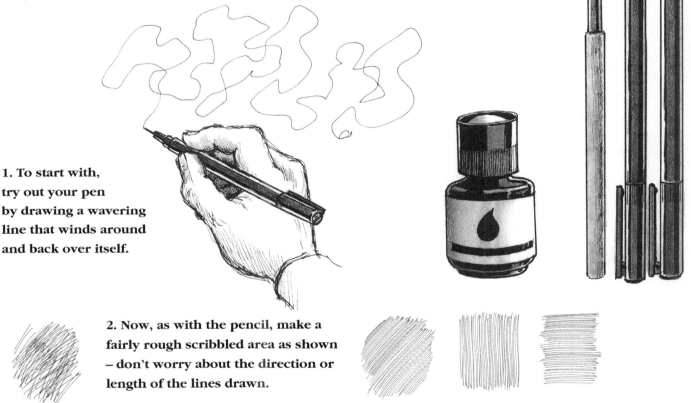

1. To start with, try out your pen by drawing a wavering line that winds around and back over itself.

 2. Now, as with the pencil, make a fairly rough scribbled area as shown – don't worry about the direction or length of the lines drawn.

 3. This time make your lines more deliberate, all in the same direction and as close together as you can without them touching.

 4. Now have a go at short marks that go in all directions and overlay each other. Keep the texture as even as you can so that there are no obvious gaps showing.

 5. The next stage is to draw patches of tone with the pen as I have shown in the examples, first diagonally, then vertically and horizontally.

 6. Then draw all the lines in four directions, overlaying them to build up a texture that can be read as a tone.

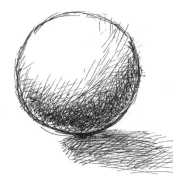

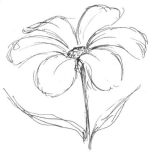

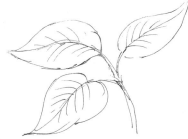

7. Next, draw a circle in ink, in the same way as you did with your pencil.

8. Now, using textured marks, as in the example, try to make a convincing sphere shape out of it.

9. Now draw a spray of leaves. Because the pen is so much more definite than the pencil you will have to draw lightly and finely, or else the lines will become too clumsy.

10. Then draw a flower head on a stalk. Treat your drawing loosely, as if using a pencil, and the marks will look attractive.

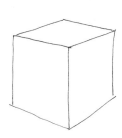

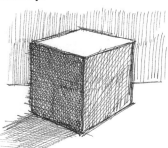

11. Now have a go at drawing the same cube shape as before, but this time in ink. Note how in the last stage the lines are quite carefully drawn in one direction and then overlaid with other lines in contrary directions to build up the tone.

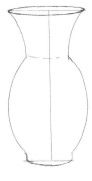

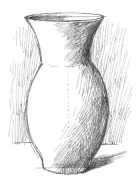

12. Now you can start to draw a real object in ink. First draw a line with a ruler, vertically and of a definite length.

13. Either side of this central line, draw freehand the simple curves of a vase. Mark the top and bottom of the shape with short horizontal lines.

14. Around the upper and lower edges, give the impression of depth by drawing an upper lip to the vase as an ellipse and a lower edge as a half ellipse.

15. With light lines overlapping each other, produce an effect of shading as I have done in the example shown. Don't forget to add the cast shadow as well.

● CHARCOAL AND CONTÉ

These mediums are favoured by many artists as they give a quicker result in terms of tone and flexibility. Charcoal comes in sticks of varying thickness, of which you will only need about two. It is very brittle and breaks easily, so you really have to use a light touch with this; it always makes a dark mark so you don't need to press at all. For something stronger and less easily smudged, try conté sticks, made of powdered graphite or charcoal compressed with a binder. Either way you will need to buy some fixative to spray your drawings with to make sure that they don't smudge; do this outside your house if possible as the fumes can be unpleasant.

1. Try making a series of scribbles with these two mediums to get the feel of them on the paper.

2. Next make a series of vertical strokes that become softer and fainter as you work to the right, as shown.

CHARCOAL

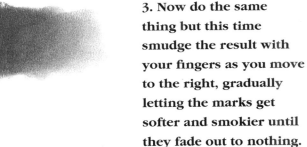

3. Now do the same thing but this time smudge the result with your fingers as you move to the right, gradually letting the marks get softer and smokier until they fade out to nothing. This is where your fingers get dirty.

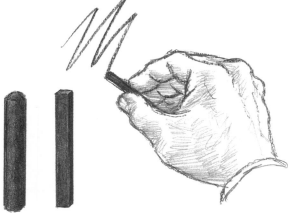

CONTÉ

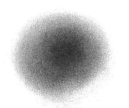

4. Now try a rounded shape with a dark centre becoming soft and smudgy all around the outside. It should look like a ball of smoke.

Now go through a similar set of exercises with the charcoal or conté stick, but this time using slightly different marks. Finger smudging helps you to give a softer edge to the tones.

 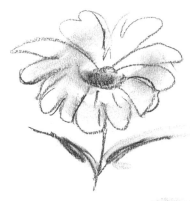

5. First, create a scribble that gets darker and darker, overlapping the marks to give more density.

6. Next, make a series of scribbly lines to produce a much lighter tone. Keep your touch on the paper quite soft, with no pressure.

7. Now make a series of dark lines then smudge them until you have something that looks like a dark cloud with no defined edges.

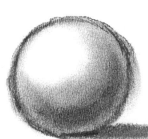 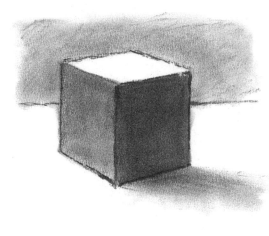

8. Now draw a circle. Draw in the areas of shadow, leaving a white highlight to give the sphere volume. Your circles will be getting better as you've done a few now!

9. Next try a cube. Build up the tone on two sides, being careful to leave the top surface white. Use your finger to create a smudged shadow to the front of the cube.

10. Finally, make some quick drawings of leaves and a flower, smudging parts with your finger to give some hint of shadows or texture.

● BRUSH AND WASH

This form of drawing uses a brush instead of a pencil and is a useful technique. You will need two watercolour brushes, sizes 10 and 2, and some dark watercolour paint or soluble ink. Buy round brushes, which come to a point when they are wet – the best type for this are those made of sable hair. Watercolour paper is the ideal surface, but if you prefer to use cheaper cartridge paper you should buy a fairly heavy one or the water will make it cockle.

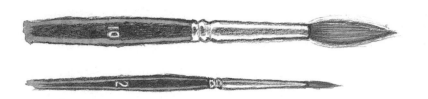

Using brushes of radically different sizes gives you plenty of choice for mark-making.

3. Now try a darker tone, gradually making it lighter as you progress to the right by adding more water for each stroke.

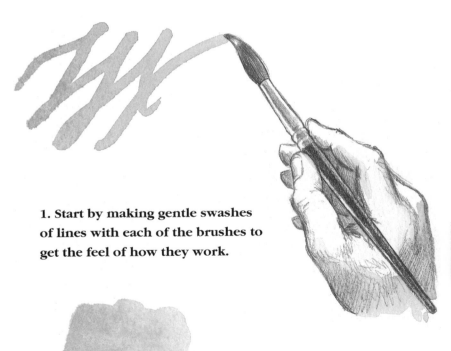

1. Start by making gentle swashes of lines with each of the brushes to get the feel of how they work.

4. Now, with the smaller brush, swish a few lines of tone without taking the brush off the paper.

2. Then make a patch of tone – quite a light one.

5. Starting with a very dark tone, dilute it down as you move to the right until it seems to disappear into nothing. Ideally you should be able to go from the very darkest tone to almost white by this method, but don't worry if at first you can't achieve it – more practice will improve your efforts.

6. Now try painting a few leaf-shapes like the ones you did with your dry mediums, only this time it will be much easier to get the shape in one stroke. When it is dry, paint in a few darker lines to show the veins on the leaves.

7. Now repeat the same procedure with a flower shape.

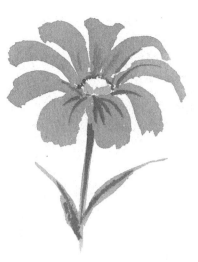

8. Again try to draw a perfect circle.

9. With another circle, put in some tone over the lower three-quarters of the shape, using a wet brush to fade out the tone near the top of the sphere. Place a cast shadow beneath the sphere, fading it off towards the outer edge.

10. Now you can draw a cube shape as before, but this time using a brush. In the first stages of drawing the cube, use the small pointed brush to make as fine a line as you can. You'll have to wait for the paint to dry before you do the next step, but if you're using watercolour paper it won't take long.

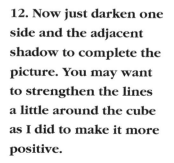

11. Paint a wash as carefully as you can with your large brush, giving a tonal background halfway down the cube and covering the two lower sides in the same tone. Also put in a cast shadow, washing it away to nothing at the far end of the shadow.

12. Now just darken one side and the adjacent shadow to complete the picture. You may want to strengthen the lines a little around the cube as I did to make it more positive.

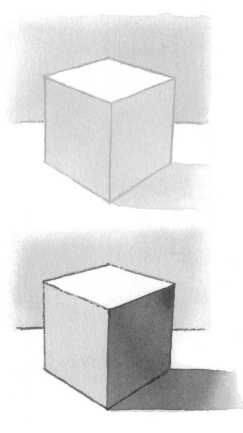

● PENCIL STILL LIFE

In the examples on the following pages I have drawn the same simple still life in different mediums, to give you an idea of the effects you can achieve with each. The exercises on the previous pages will have given you valuable experience in handling these mediums, so you may now be ready to have a go at reproducing these yourself. I encourage you to draw from life as often as you can, as it will quickly improve your drawing and will also teach you to see more accurately and perceptively.

For this still life I placed a bowl of plums on the table in front of me and lit them from one side, without any particular background. This made a series of clear shapes without any complicated drawing to be done.

1 First make a very rough pencil sketch of the main shape of the objects to make sure that you are seeing it accurately. Once the result pleases you, draw it up more carefully, using an eraser to correct any mistakes.

2 When you are drawing the objects with more defined lines you should make as many corrections as you need to, because this is the time when it's relatively easy to do. Later on it becomes more difficult.

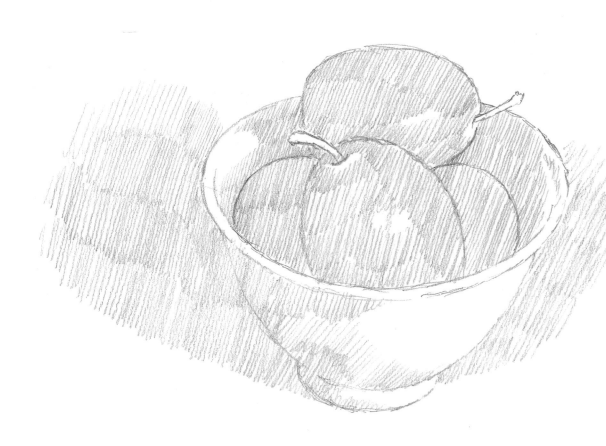

3 The next stage is to mark in the main areas of shadow on the objects with a light and uniform tone. Don't be tempted to put in the darker tones yet, because you may find it more difficult to make any corrections.

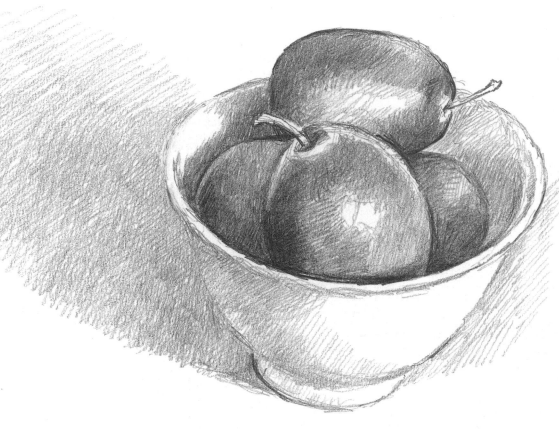

4 When you're satisfied that all the areas of shade have been covered by your light tones, you can put in the darker ones. A good way to do this is to put the very darkest first and then work in all the mid-tones afterwards, but you may prefer to tackle it another way. However you do it, keep checking the whole drawing to see how the effect is progressing.

⬤ PEN STILL LIFE

Drawing up the same still life in ink is rather like working with a pencil, except that you can't merge the marks so easily to make the tone. However, the principle is exactly the same in that you build up the tone after you have drawn the outline of the main shapes.

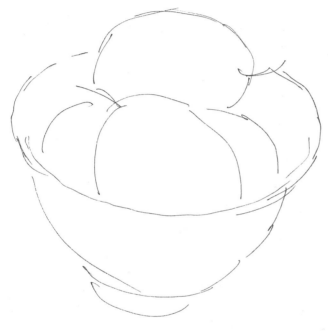

1 Sketching in a rough outline should be done very lightly, because you will not be able to lose the marks. Make them very fine in thickness and rather broken in line.

2 When you're firming up your outline drawing, take as much time as you need to make the image as accurate as you can.

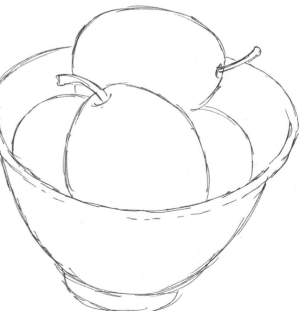

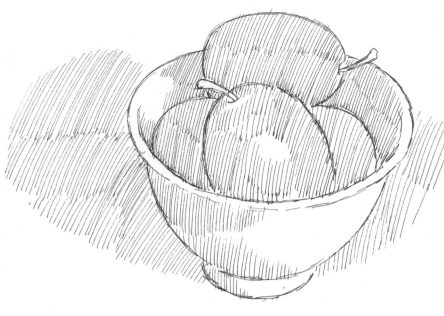

3 Then, as in the pencil image, you'll need to put in the overall area of tone with light strokes, not too close together. It doesn't matter if the strokes don't all go in the same direction – just don't make the tone too heavy at this stage.

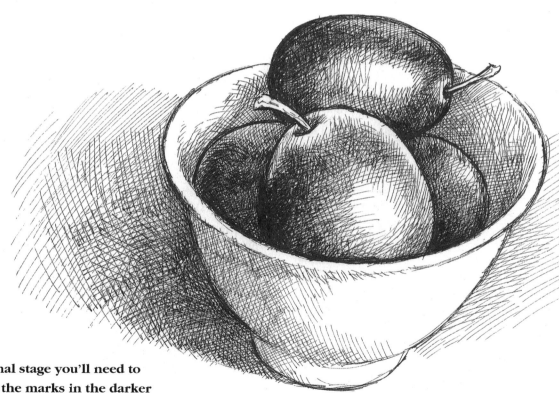

4 In the final stage you'll need to build up the marks in the darker areas as before, judging the weight of tones in the image as you go along. This layering of strokes one set over another to make a sort of lattice-work is called crosshatching. In this way the tone can become darker and darker as you add each layer of closely drawn lines.

● CHARCOAL STILL LIFE

As you can probably guess, when you draw the still life in charcoal the same rules apply as with pencil and pen. The main difference is that you have the smudge factor to make the job quicker, if not quite so precise. My advice is to draw in charcoal on a bigger scale, when the slightly chalky line seems to be more effective.

1 With this softer drawing medium the first lines aren't so crucial as it's quite easy to alter them. However, keep them light and sketchy at this stage, making alterations as you go along. The process of correcting your drawing is never a waste of time because this is how you learn to improve your skills.

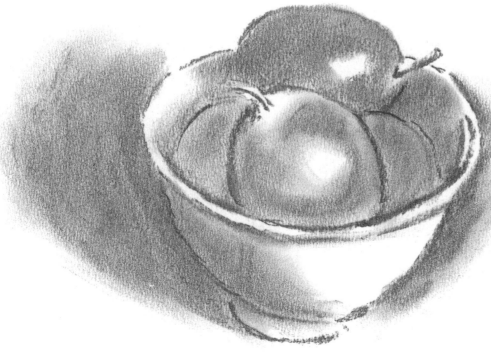

2 Put in the main area of tone as with the other techniques, but this time you can smudge the tones a bit to keep them light and soft-edged. Don't go over any area where the light is strongest as white paper helps to give the highlights impact.

3 Then build up the darker tones, smudging only lightly to avoid smoothing out the texture of the drawing too much, which can make it look a little too glossy.

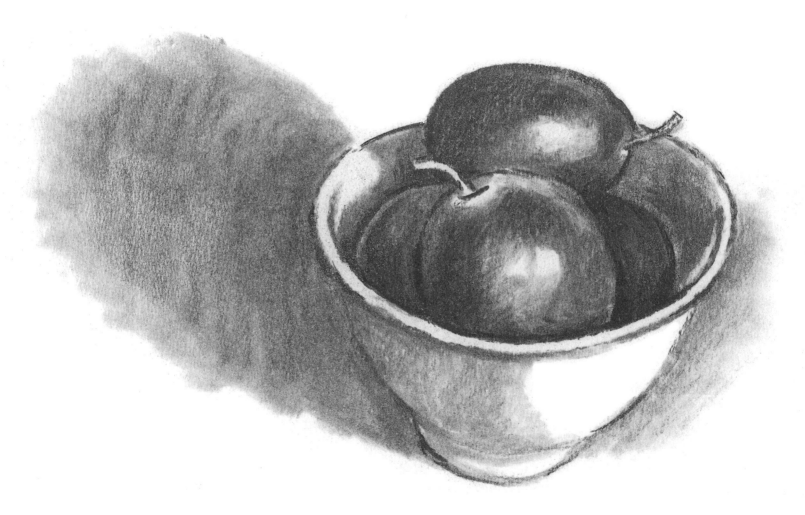

● BRUSH AND WASH STILL LIFE

With the brush and wash version you can lend the surface of the objects a very realistic look, which is the great advantage of paint over pencil. Of course it's not quite so easy to control, but you'll soon become good at it if you keep practising. The convincing effect of this method makes learning to handle it well worth while.

1 The first outline drawing, rather like the pen drawing, needs to be done fairly carefully, although it is easier to change than the ink version. However if you can keep it very spare it helps for the later stages. Don't have the brush loaded with too dark a tone – keep it light.

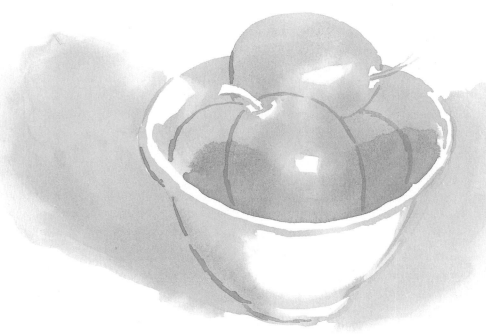

2 In the second stage the laying on of the single light tone can only be carried out when the first marks are dry, otherwise you will find the area flooding with too much tone.

3 In the third step, lay on the darker tones when the light tone has dried, but you may have to soften some of the edges by watering down the colour sometimes. This in a way is the hardest part of the brush technique, so don't be too upset if it doesn't always work. This is where practice comes into force; the more you try it out the better you will get.

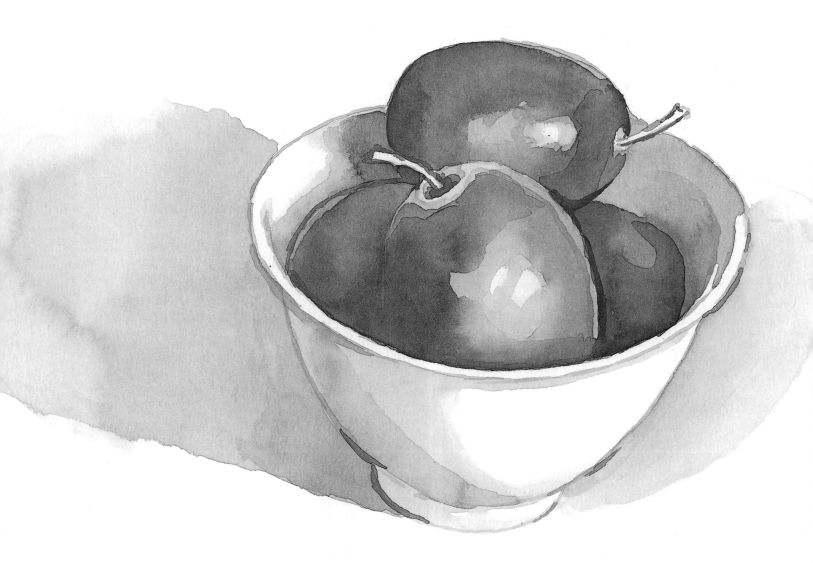

CHAPTER 2
LINE DRAWING

Once you've become familiar with the marks that different drawing materials make you can really get going on drawing from life, and anything is useful for your practices. In this section we'll concentrate on making line drawings of a range of subjects without worrying too much about tonal detail at this stage.

● SIMPLE SHAPES FROM EVERYDAY THINGS

Starting with a circle drawn using a compass, test your efforts to draw a freehand circle accurately. Draw them side by side for comparison and keep rubbing out any obvious mistakes until the hand-drawn circle looks as effective as the compass-drawn one.

Then try out these figures by copying them – a cube, a cylinder and a cone in two positions.

Now find an ordinary wooden box and do your best to reproduce some form of the shape as shown here, with its perspective effect. Notice how the far end of the box appears to be slightly smaller than the closer end. We'll be looking at the laws of perspective on pages 76–89, but for now just rely on observation.

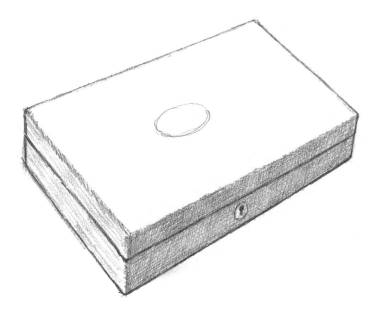

For your next practice, find a series of ordinary objects from around the house and have a go at drawing them in a very simple way. There's no need to look for items with an inherent beauty – this is just about learning to draw things accurately.

Here's a little glass bottle containing some pigment that I found in my studio. It's based on a circular shape, so, as you can see in the drawing next to it, the sides show as mirror images either side of a central line.

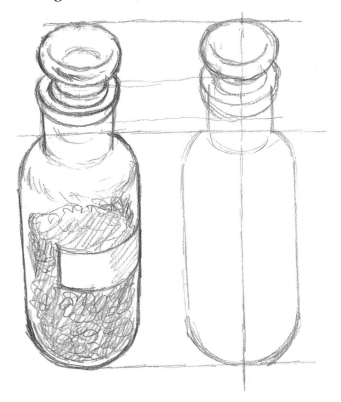

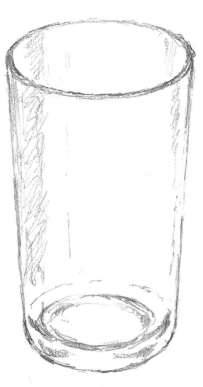

This is also true of the next object, a glass tumbler. Many of the objects you will find in your kitchen are based on circles or squares.

Next I tried a wine bottle, which, as in all these drawings, I drew without too much tone or attempt to show anything except for the shape. Always keep things as simple as you can at the start – it's the best way to learn.

The next object is a bowl with a spoon, such as you might use to have your breakfast cereal. This is a bit more difficult, because the spoon is resting on the bottom of the bowl and your drawing needs to make that look right.

The value of glass objects is that you can see through them and so get a better idea of how the shape works. If you don't get the shape accurately drawn, the tonal values you may put in later won't help to convince the viewer that your object looks like it should.

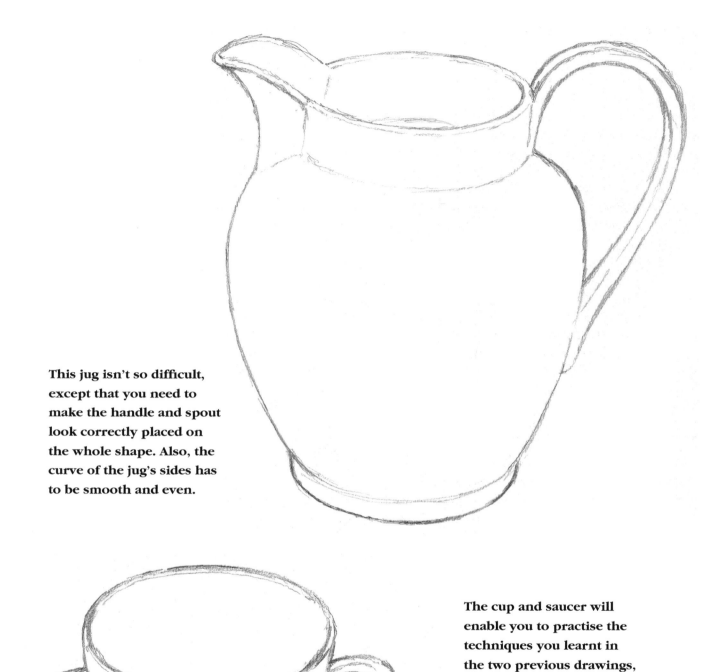

This jug isn't so difficult, except that you need to make the handle and spout look correctly placed on the whole shape. Also, the curve of the jug's sides has to be smooth and even.

The cup and saucer will enable you to practise the techniques you learnt in the two previous drawings, because the cup has to rest on the saucer convincingly and the handle must look firmly attached.

● TREES AND FLOWERS

Even if you live in a town, you probably
have some vegetation near you in a garden
or a park. Go and have a look at some trees,
and notice how complex they are, with their
myriad leaves and branches. One student of
mine, when confronted with a tree to draw,
said, 'Do I have to draw every leaf?' Of course,
the answer is no – but you do have to make a
tree look as though it has leaves en masse.

As you can see, these first
sketches help to establish
the proportion and overall
look of the trees without
much drawing.

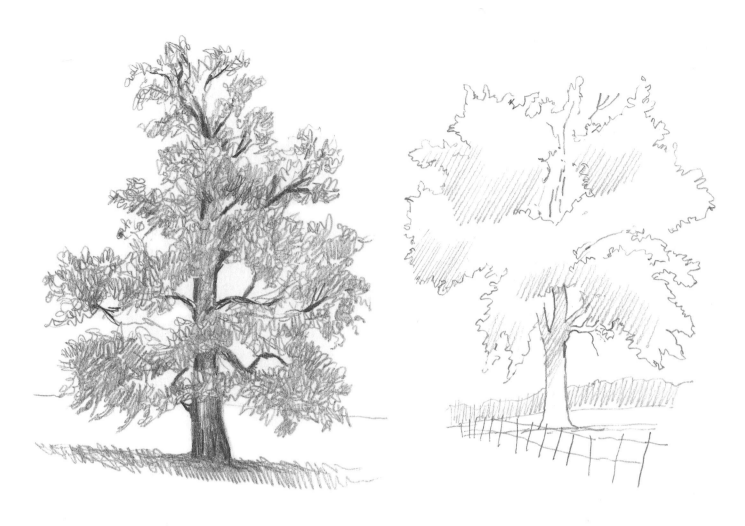

In the three drawings on this page, I've shown how you can indicate leaves with a sort of scribble technique so that they look softer and less definite than the trunk and branches; or you can outline whole masses of leaves and just put a tone over the areas where the shadow is deep. Alternatively, you can simply outline the whole shape of the tree without worrying about the different parts.

Flowers make excellent subjects for practising your drawing skills upon because they can easily be picked out from the background vegetation and have quite complex shapes.

These rose and clematis flowers present interesting shapes and need to be carefully studied in order to get the feel of their delicate texture. At this stage, just concentrate on getting the shape right; later, when you're more expert, you'll want to achieve a more sensitive rendition.

● LARGER SHAPES

Now let's look at something bigger and man-made. This is an ordinary iron garden chair that's not only very traditional, but in this case fairly old and worn – it's a chair from my own garden, in fact. Because of its linear shape it's ideal for this practice.

1 First draw a skeleton of lines that gives you the main shape of the chair without any detail. At this stage, get the basic cubic shape right by projecting lines down from the seat to the points where the legs meet the ground. The crossed side pieces that make up the legs of the chair meet at about the middle of this cube.

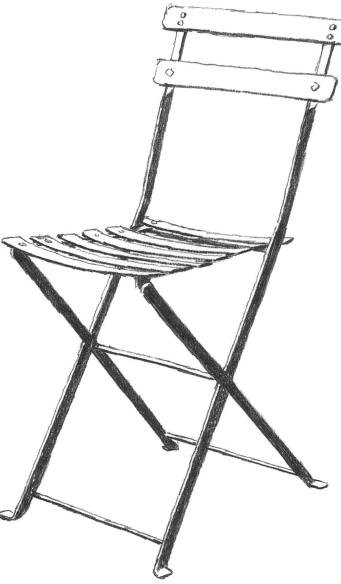

2 Now carefully draw up a more three-dimensional shape, showing the pieces of flat metal that the chair is constructed from. At this stage use an eraser as much as you need to in order to get the shapes correct.

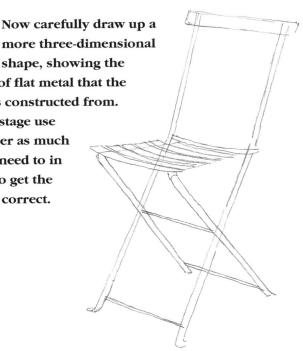

3 Now make the darker sides of the strips of metal quite black and sharply defined with your pencil, leaving the lighter edges of the side facing the light drawn less strongly. The effect of this is to give more solidity to the form of the chair.

1 Now we'll go even larger. I've chosen a garden shed, but if you haven't got one just draw any small wooden hut you can find. The first thing to concentrate on is successfully giving a three-dimensional effect to the hut by using perspective. This is fully explained on pages 78–89, but all you need to know here is that once you've drawn the nearest corner first as a vertical line, all the horizontal lines of the building going away from you should converge so that if they were extended they would meet at your eye level.

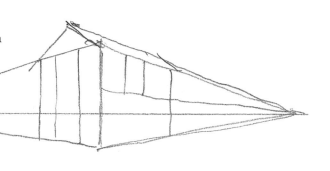

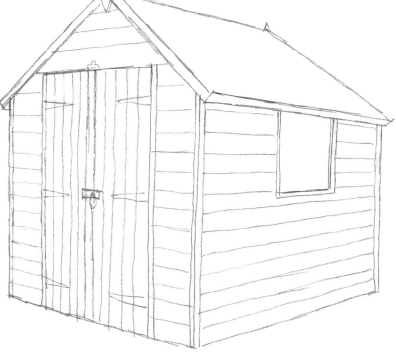

2 To start with, put in only the outline of the building, leaving the details until you're confident you've got the shape right. You can see how the use of perspective immediately conveys the sense of a three-dimensional structure.

3 Now put in as much detail as you can, working carefully, but only in line at this stage. Take as much time as you need and use an eraser to correct any parts that don't look right to you.

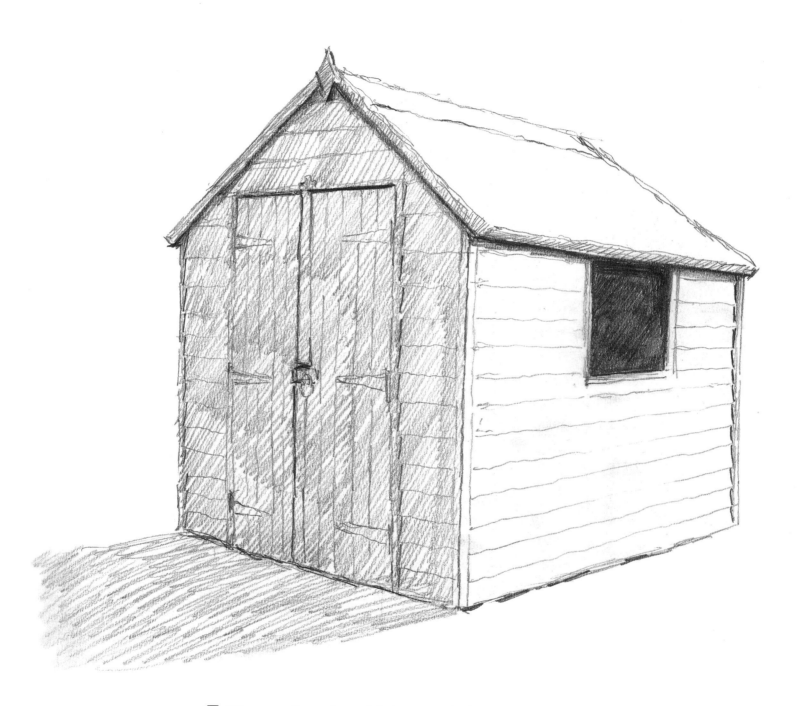

When you have done this just try a little tone by putting one side in shadow and darkening any windows to give them a feeling of depth. As you can see, even with quite minimal tonal areas the hut looks more substantial.

● DRAWING PEOPLE

The human figure is probably the most challenging of all subjects for an artist, partly because our familiarity with it means we can see immediately when a drawing isn't convincing. Because of this, you'll need to practise drawing people much more often and with more intensity than most other subjects. However, starting isn't any more difficult, because at this stage you'll be drawing in a very simple fashion.

HANDS

We begin with hands, because you can draw your own – they have the advantages of being very well-known to you and always available!

1. First, draw around your hand to familiarize yourself with its proportions on paper. Place your hand flat on the paper and carefully trace around it.

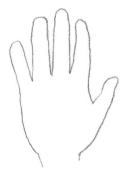

2. You won't obtain an exact rendering of your hand with this method, but you'll be able to see quite clearly from your drawing the length of the fingers contrasted with the shape of the back of the hand.

3. Now, keeping your original drawing close at hand so you can check against it, place your hand flat on the paper again and, next to it, make a careful copy without drawing around it. Your first drawing will probably be a bit too fat for reality but keep on trying, remembering that the first drawing will be correct proportionately. Once you feel happy with a freehand drawing of your hand, draw it in various positions.

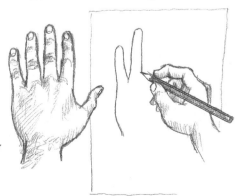

4. With the fingers bent slightly, seen from the top.

5. With the fingers spread, seen from the side.

6. And again from the other side.

7. Then with the fist clenched, seen from the thumb side.

8. With the fist clenched, seen from the knuckle end.

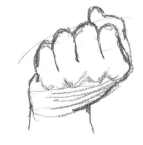

PRACTISING DIFFERENT ANGLES

Now try drawing as many hands as you can from many different angles. Notice how on some of my drawings I've simply drawn the fingers as a broad chunk, just putting in the marks where the knuckles bend. The important thing is to see the main structure of the hand in an almost architectural way. Hands are very complex, and the more you can do to simplify the drawing of them the more you will learn about their basic qualities. All drawing has to go through a process of simplification until you are convinced of your own knowledge of how a construction works.

FEET

The obvious part of the body for you to draw next is the foot because, as with your hands, you can draw your own feet quite easily – especially if you have a mirror handy to see them from various angles. There is so much less movement in the foot than in the hand that it's not such a difficult thing to draw. The greatest problem is that we don't normally look at feet much, so the shapes won't be so familiar to you.

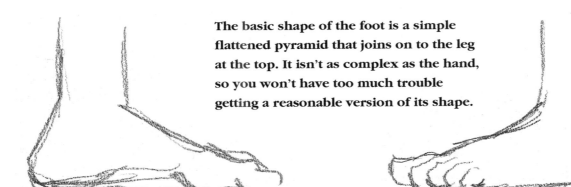

The basic shape of the foot is a simple flattened pyramid that joins on to the leg at the top. It isn't as complex as the hand, so you won't have too much trouble getting a reasonable version of its shape.

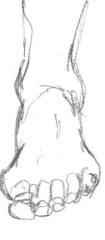

The hardest views are directly from the front or back, so you may have to look at those rather more carefully. The front isn't a problem to see if you have a mirror, but the back might be easier if it is someone else's foot.

Even the underneath of the foot can be seen in a mirror, so you shouldn't have too much difficulty.

THE HEAD AND FACE

When it comes to drawing the head, a common error that novices make is to concentrate on the face without paying much attention to the rest of the skull. In fact, the rest of the head is much larger than the area occupied by the face, but people often fail to notice this because their interest is caught by the facial features.

In this drawing, the dotted line shows the limit of the area occupied by the features of the face.

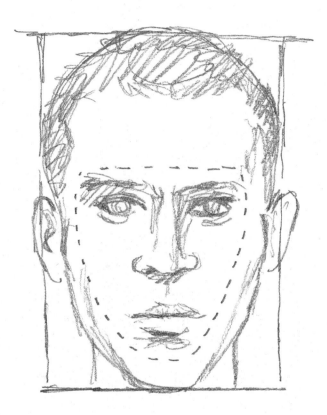

To discover the truth of this for yourself, draw a square first, then draw a skull inside it. You can copy my drawing, because you probably won't have a skull handy! Notice how the eye sockets are halfway down from the top of the skull. This is rarely spotted by novice artists. You'll find more detail on the proportions of the head on pages 72–3.

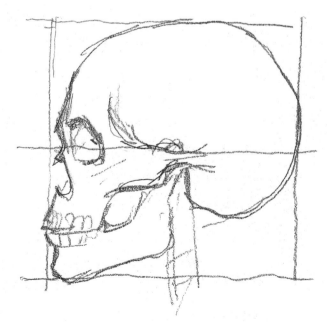

SKETCHING HEADS

Here I have drawn the heads of five different people, which show how we all look very similar under the surface. Each of the initial drawings is of a skull, which only shows you the basic shape of the head.

The next stage shows the outlines of the individual heads and the placing of their features. At this stage the hair hardly registers, and although you can see that there are some differences between the faces they're still very slight.

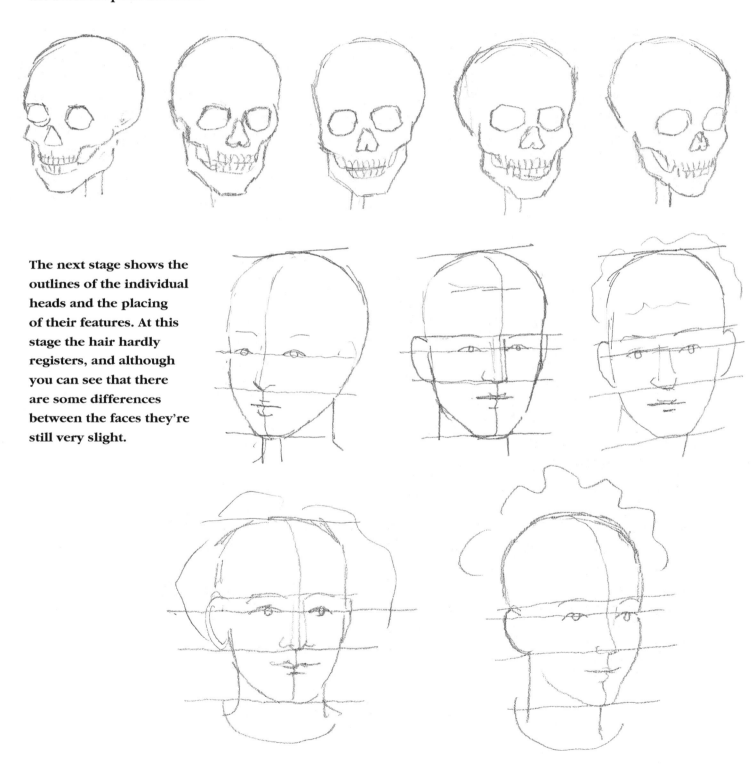

In the last stage I've put in all the particular features that turn these drawings into portraits of two young women and three young men. It's the finer features of the women and the hairstyles that create the differences between the main shapes of the male and female heads, but the details of the features make the heads more individual. If you met these people you wouldn't mistake one for the other, though you might not have spotted much difference in the skulls.

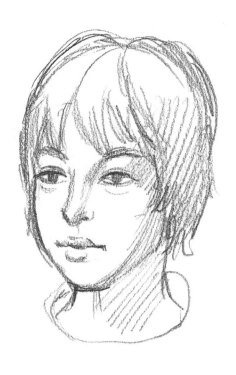

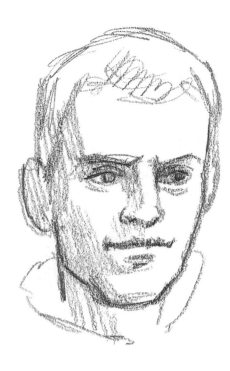

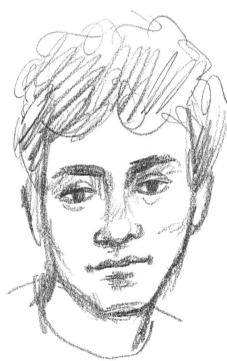

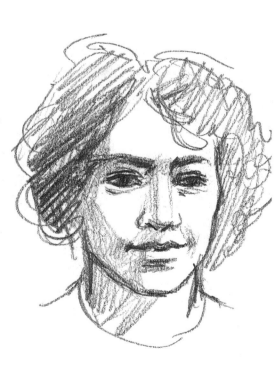

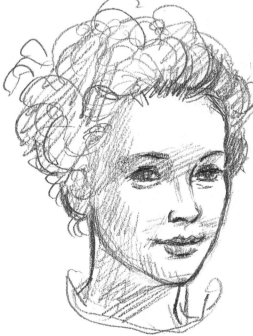

This exercise will have helped you to realize that one face isn't more difficult than another, because all faces have a basic shape so similar that it's only the final details of the features that make them distinguishable. Always draw people as though they were the same, but bring in the individuality with sensitive delineation of the final look.

41

● DRAWING A PORTRAIT

Now you have some idea of how heads are formed, try making a simple portrait. You can always do a self-portrait in the mirror if you can't find a model, but at this stage it's better to draw someone else. Alternatively, you can use a large, very good photograph as long as the subject's head isn't tilted backward or forward.

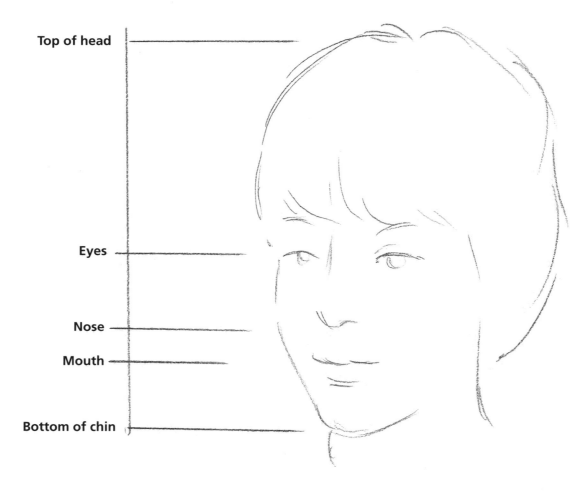

Top of head

Eyes

Nose

Mouth

Bottom of chin

I Pose your model with the head level and facing slightly towards one side, looking past you, so that you can see all the features clearly. Make a mark which indicates the very top of the skull, and another mark to indicate the bottom of the chin. Halfway down that length mark the level of the eyes, then in the lower half make a mark about halfway down to place the tip of the nose. The mouth will be in that lowest quarter, closer to the

nose than to the bottom of the chin. See if you can judge it by eye.

Having marked up the placing of the major features, now draw a head shape that looks like your model's, keeping your line very light and loose. Then you will need to mark in the eyes, nose and mouth, still very simply. At this stage, don't attempt to achieve a likeness – your task is just to get the main shapes correct.

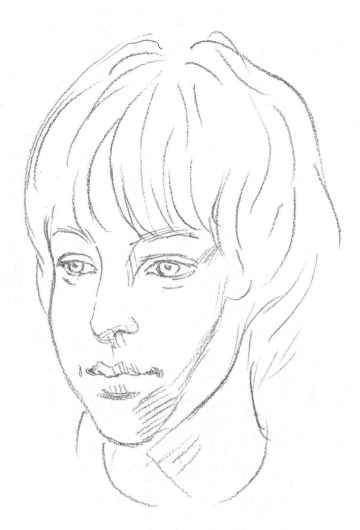

2 Having satisfied yourself that the shapes of the head and features are as they should be, you can now start to draw in the rest of the head. Make sure that everything you put down is as you see it on your model, and don't be surprised if this takes quite a long time. It's better to get everything right at this stage to avoid having to make corrections later on.

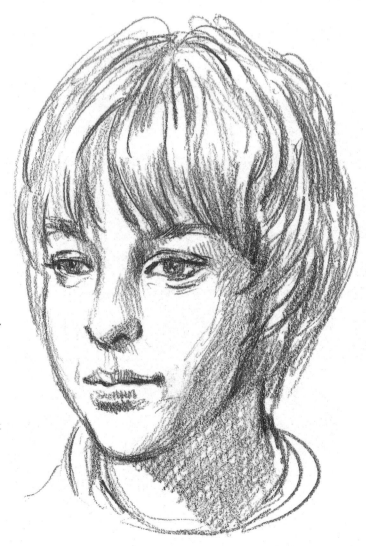

3 When everything looks as it should to you, try out a bit of tone on the head to indicate the direction of the light. As you can see, the light is falling on my model from the upper left-hand side so all the darkest shadows are on the right of the head.

CHAPTER 3

TONAL DRAWING

Tone helps to give a three-dimensional effect to a drawing, so it's important to be able to use it effectively. As you'll have realized by now, regular practice brings improvement to your drawings, so take plenty of time in your explorations of tone.

● EXERCISES IN TONE

As a start, I've given you some patches of texture or tone just to get the idea across. If you draw series of five squares alongside each other as shown, you can then proceed to fill them in with your different mediums.

The first square on the left should be filled in with the darkest area of tone that you can manage with pencil, pen, charcoal and brush and wash. As you can see, the square at the far end is in all cases completely white, with no tone or texture in it at all.

Next you have to try to balance your tones so that the remaining three squares in each panel give a very dark but not black tone, a mid-tone and a very light tone. The effect should be to see a natural change in tone from dark to light as your eye wanders across the five squares. If any of them seem to blend too much with the adjacent ones or, conversely, jump out too much, you haven't got it right yet. You may need to have several goes before you come up with the ideal graduation of tone from black to white.

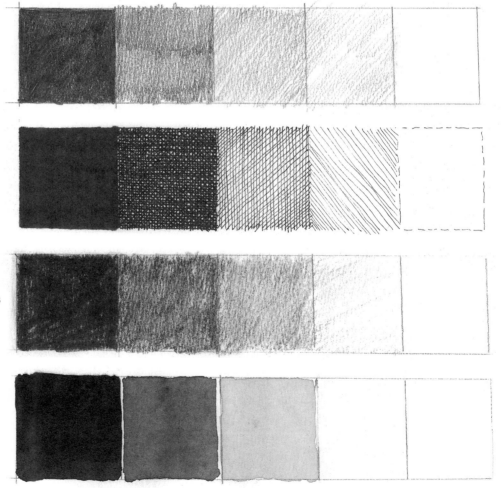

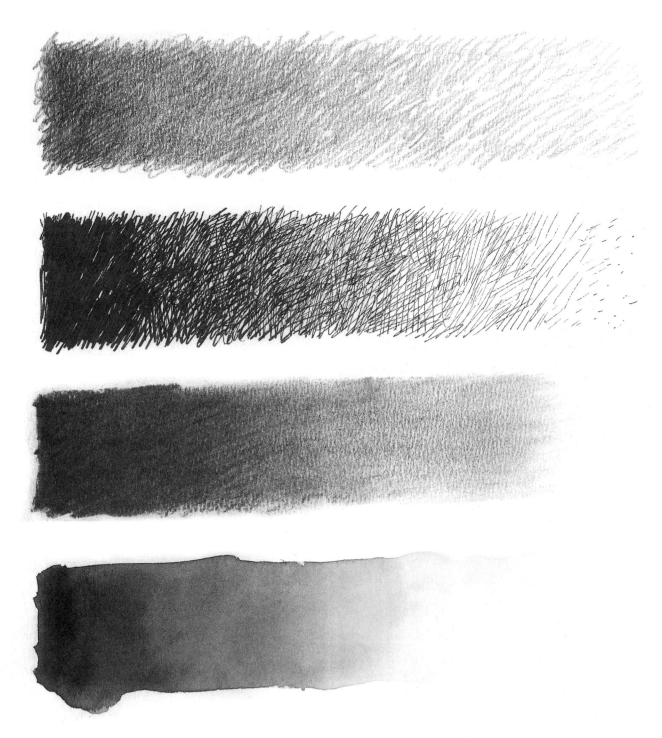

Then try doing a swatch of tone that starts at the left end as black and fades to the right until it's white. In the pencil and charcoal versions you'll be able to smudge the tone a bit to make it work more effectively, but with the ink and the brush and wash you can't do that. Adding water to the wash version is the key, but the ink just has to be done with careful working over the texture of lines, gradually ending up with hardly any.

● TEXTURE USING PEN AND INK

Texture is another way of defining the objects you're drawing, and as pen and ink is such a definite medium, using texture is the only way that you can express tonal values. So here I have drawn a whole group of textures that you may need when you come to do any drawing in this medium.

Short marks in various directions.

Longer marks.

Very long marks.

A texture rather like woodgrain, with no lines overlapping.

A wiry scribble that goes back and forth across itself.

An endless wiry line that doesn't ever cross over itself.

Much heavier short lines with a No. 0.8 pen.

Longer lines with a No. 0.8 pen.

The woodgrain look with the No. 0.8. pen.

A dotted technique.

Groups of short lines in clusters.

A wiry line with a No. 0.8 pen.

A series of small leaf shapes covering the area.

A layer of zigzag lines across the area.

A net of horizontals and verticals.

A series of tiny blob shapes.

Shapes like a series of fish scales.

Very light lines like a series of fine scratches overlaying each other.

● TONE ON AN OBJECT

It is only once tone has been added that an object begins to look like something three-dimensional that you can handle and use. The following drawings show just how important it is to be able to use tone to describe the substance of objects.

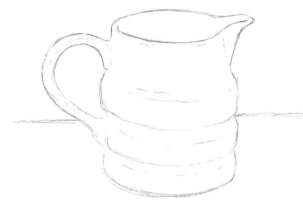

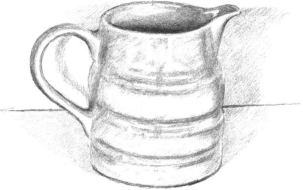

1 Here I've drawn a light-coloured jug, first in outline to show how the shape alone, if well described, will give you quite a lot of information about the jug. You can see that it must be round and that it has a lip and a handle, and it appears to be on a surface, the limit of which you can see behind it.

2 In the next drawing all the tone has been put in to show the difference that this makes to our knowledge about the object. The space is more defined and the quality of the curve of the jug is more clearly seen so you get some feeling of its solidity.

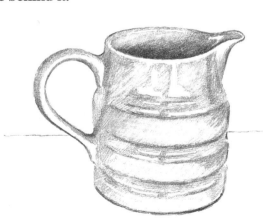

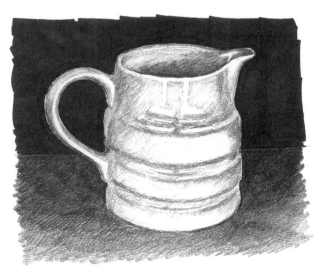

3 In the next drawing I have put in all the tone on the jug but have left out the tonal background. This has the effect of making it appear to float in the space, because it hasn't any real connection with the background.

4 The last drawing of the jug does the opposite, making the dimensions of the object loom out of the darkness of the background, so that it's very clearly defined as light against dark. This isn't in fact realistic, but it's a good way of bringing our attention to the jug shape jumping out of the space. So you can see that tone can add or subtract quite a bit from your drawing.

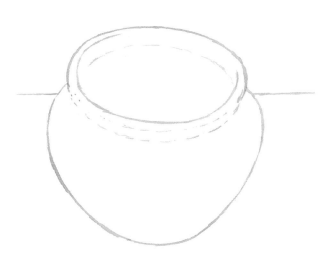

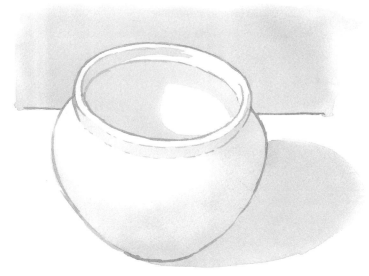

1 Here I've drawn a simple brush and wash version of a white pot against a white background as an exercise in producing shade with this medium. It is in three stages, showing the first outline drawn in with a fine pointed brush.

2 Next I put in the whole area of shadow on the pot, the surface it's resting on and the background, using one light tone only.

3 I had to wait for the first layer of tone to dry before putting in the darker tones to emphasize the roundness of the pot, building them up with care to let the edges of the tone blend in.

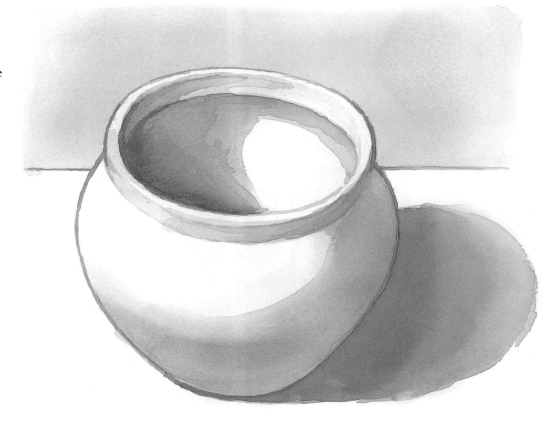

⬤ EXPLORATIONS OF TONE

Once you've tried using tone on simple household objects you'll be ready to tackle tone on more complicated subjects. It's not more difficult – you just need to observe where the light is coming from and be consistent with where you place your shadows.

1 The first stage is an outline drawing of a head – at this stage the only requirement is for a clear and correctly proportioned shape that includes the position of the features and the area of the hair.

2 In the second drawing the shapes of the features are more clearly described and you can gain some idea of the solidity of the head without yet seeing any of the form defined by tone.

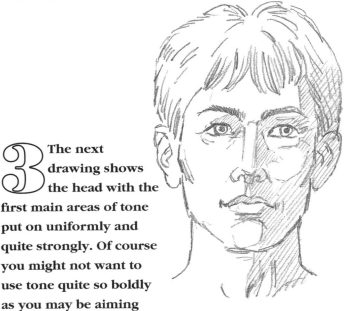

3 The next drawing shows the head with the first main areas of tone put on uniformly and quite strongly. Of course you might not want to use tone quite so boldly as you may be aiming for more subtle areas of shade, but this gets the idea across.

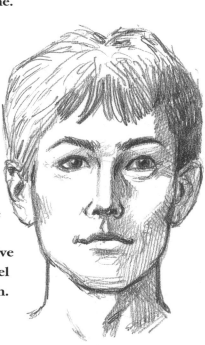

4 In the final stage you can go full tilt at the tonal area and show some parts darker to give the most convincing feel of dimension and depth. At this stage you might decide to soften some edges of tone as well.

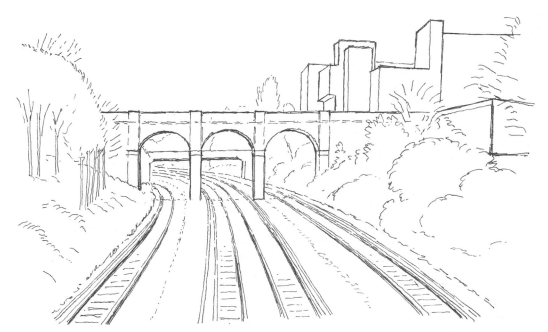

1 Now an example of the tonal work in a landscape picture. This view from a bridge over the railway near Putney, in London, gives a good example of perspective, which is emphasized by the railway lines curving from under two bridges towards the viewer. This in itself will give a sense of depth even without any tonal work. The drawing at this stage needs to be accurate and well-defined to show the various buildings and vegetation in proportion.

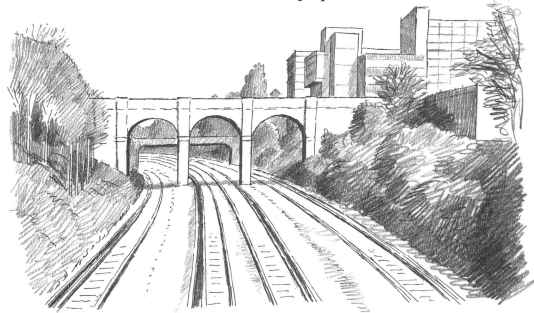

2 Quite a lot of the tone that is put in next is on the vegetation, which always tends to look darker than the surrounding buildings unless the building is in deep shadow or the sunlight is very strong on the leaves. As you can see, the tonal work emphasizes the depth and space in the picture, especially around the bridge area, where the shadows under the arches are very strong, and along the length of the railway lines, which stand out in the foreground.

● HOW MASTERS HAVE USED TONE

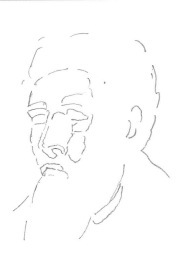

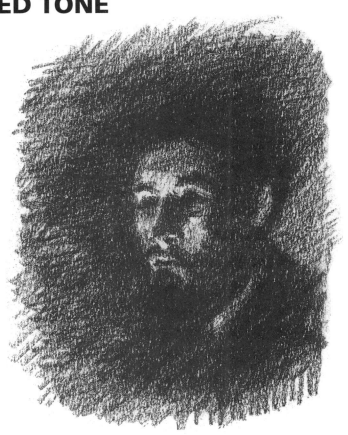

Ernest Laurent drew the face of fellow-painter Georges Seurat in very low light (probably from a candle), which demonstrates how much can be implied by so little. I've drawn an outline of the actual amount of definition shown, but we read a lot more into his drawing in terms of depth and form.

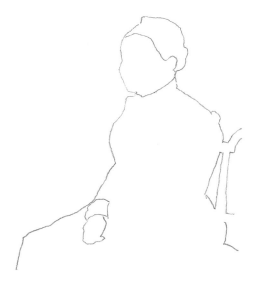

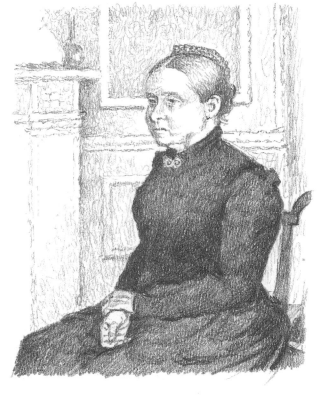

With Théo Van Rysselberghe's drawing the main shape of the figure is shown with much denser texture and tone than the background and this helps to give her a dramatic intensity in the space. I've drawn an outline as before to show the main shape of the figure. This way of separating the foreground from the background can work very well.

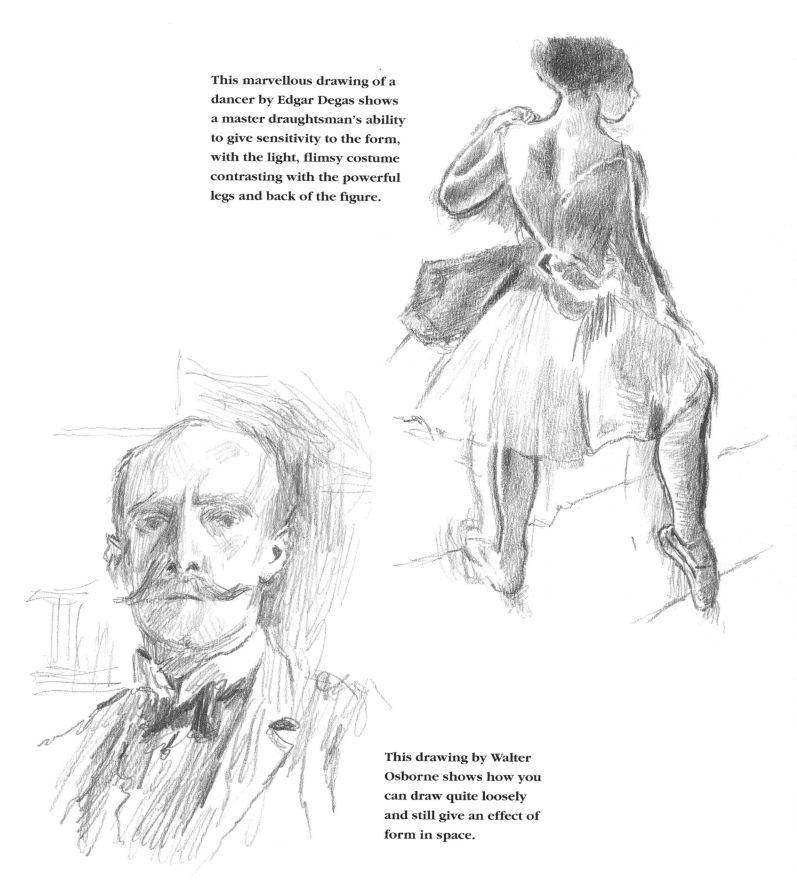

This marvellous drawing of a dancer by Edgar Degas shows a master draughtsman's ability to give sensitivity to the form, with the light, flimsy costume contrasting with the powerful legs and back of the figure.

This drawing by Walter Osborne shows how you can draw quite loosely and still give an effect of form in space.

The drawing of ruins by
Herman van Swanevelt gives
an impression of the weight
and solidity of the chunks of
masonry against the light with
the use of finely drawn lines.
Notice how the nearer stone is
much denser in texture than
the arches, although just as
clearly defined.

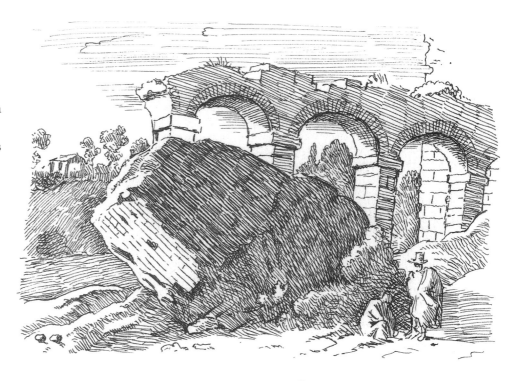

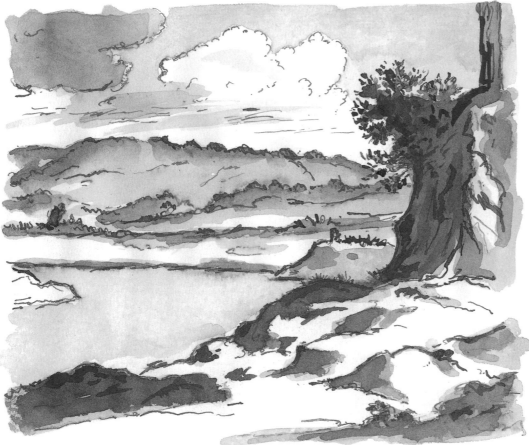

Claude Lorrain's view of
the Tiber gives a good
lesson in the use of
brush and wash, with
the addition of some
inked lines. Notice how
the nearer areas are in
darker tones and have
stronger texture than the
farther landscape.

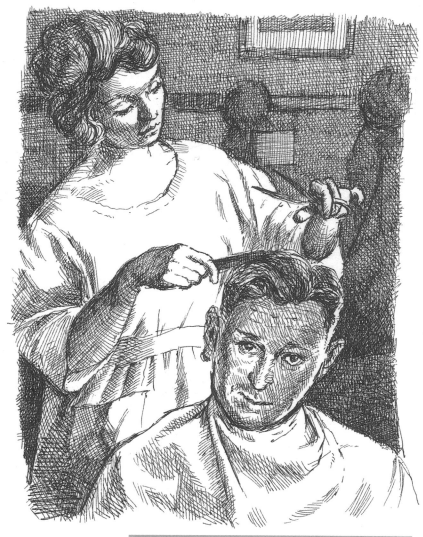

Here's a good example of the use of fine lines of pen-work building up a substantial and dramatic picture of an ordinary enough event. Russell Reeve has used the light shining on the hairdresser's overall and the cloth over the shoulders of the customer to great effect. The dark masses of texture in the background give a rich quality to the picture.

In this modern version of the Gainsborough that I have done myself, the dark and light tones are strong but the colour of the paper does most of the work.

Using toned paper allows the artist to eliminate one area of tonal work as the paper acts as the mid-tone, leaving only the dark and light tones to be drawn. Thomas Gainsborough's approach is very subtle, using quite a lot of the darkest tones and applying the lightest tones only sparingly.

● TONAL DRAWING PRACTICE

Having looked at some of the possibilities of tone, we can now turn our attention to some straightforward objects for you to practise your technique on.

First, a drawing in ink of an apple. The build-up of tonal texture is done in a scribble technique, which seems to work well with rounded objects.

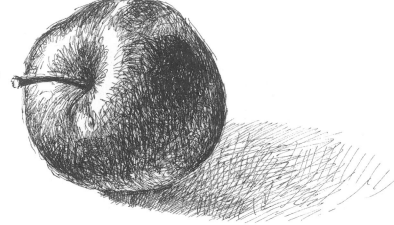

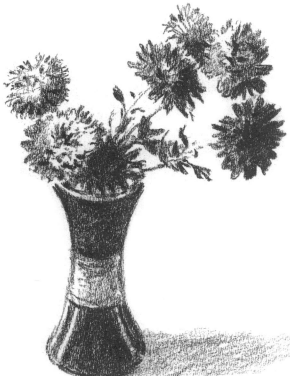

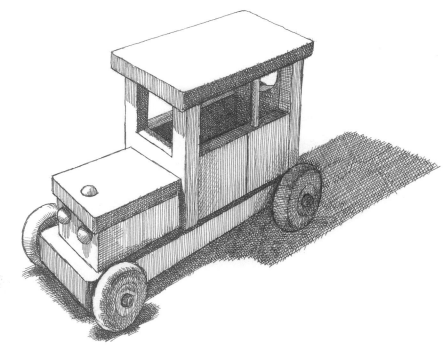

The flowers are drawn in charcoal, and the soft edges of the medium suit the quality of the plants. The slightly woolly texture of the blossoms is easily shown in this medium.

Because of its straight-edged manufacture, this toy seems a good subject for using pen and ink. You can draw most of the main tone in lines that echo the lines of the form, so lots of verticals and horizontals to start with, and then a few diagonals to deepen some areas in tone and texture.

The brush and wash technique helps with the drawing of a leather bag, its slightly squashy look being easily adapted to this technique.

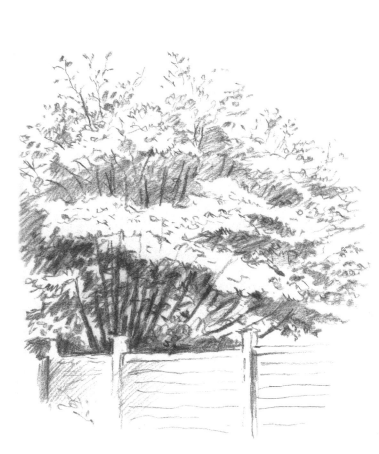

A careful pencil drawing suits a white pestle and mortar, with the shadows put in as pale tones, since a light-coloured object would only have dark tones if it were subjected to very dramatic lighting.

Some trees seen over a fence are easier to draw in charcoal, because this medium is sympathetic to the soft clumps of leaves.

TONAL DRAWING

Here are two examples of how to put together a drawing which largely relies on tone for its effect. One is of a girl sitting in front of a fire in the evening, and the other is of a large tabby cat. Both are mostly made up of changes in tonal density rather than definite lines to show their substance; in neither of them are lines much in evidence.

1 In the one of the girl fire-gazing, a very simple outline is all that can be drawn, showing the areas of differing tones. The only point of the outlines is to make sure the proportions are correct.

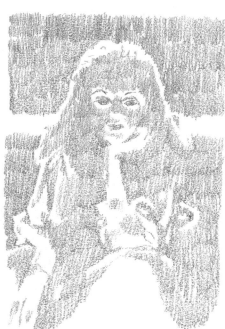

2 Then put in the shaded areas all as one tone, leaving white paper for the highlights.

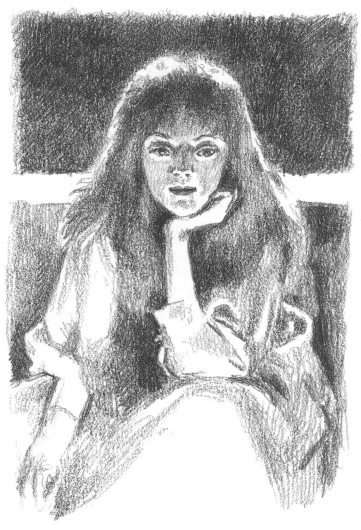

3 Carefully darken the areas that need to be stronger until you are satisfied that the picture is strong and convincing.

1 Drawing the cat is a similar exercise, except that the tone is much more descriptive of the pattern on its fur. Start with an outline of its body and loosely indicate its face and stripes.

2 Cover nearly all of the cat with a simple tone – there are very few areas of white in this picture, and they appear mainly on the face and chest.

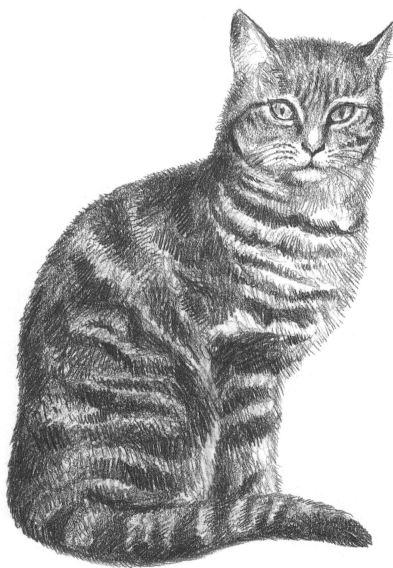

3 Finally, draw into the main areas of darker tone to bring out the stripey appearance of the fur.

CHAPTER 4
OBSERVATION IN DRAWING

To become successful with your drawings, the most important skill to develop is to observe your subject carefully, with patience and visual intelligence. In daily life, most people look at the world around them just for the purpose of recognition, but to be able to draw anything to a good standard it's critical to look long and minutely. In fact, this is a good thing to do even when you're not drawing, as it becomes second nature if you practise often enough.

● OBSERVING THE NATURAL WORLD

Presented with the two examples of plant life on this page, most people would just register that one piece is leafless and dead while the other has leaves and flowers. For you as an artist, this isn't enough; you need to look at the nodules of lichen and notice how they subtly change the shape of the twigs, and the way the dead twigs project from the main part of the branch, giving it a sculptural quality. It's not just a dead branch, but a very interesting space divider, creating decorative spaces around it.

Conversely, when you look at the plant with leaves and flowers, there is the shock of the growth effect of this vigorous plant, which shows up the light, delicate flowers against the darker leaves and background. Here everything is full of life, thrusting out of the damp earth. This plant does not stand still like the dead stick, but moves and grows all the time, giving a liveliness to the experience. One feels that in a few hours the whole plant will have changed its display as it continues to grow.

So drawing these two plants isn't going to be an ordinary experience because much more can be seen than was evident at first glance. This observation by an artist is why a drawing or painting can stimulate the imagination of the viewer, because when they see the drawing they start to see what the artist may have experienced.

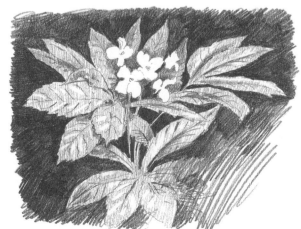

Let us now take this further and look at some trees. Here are two examples, the first of which is an old tree trunk seen in close-up from below. It almost ceases to be a tree, becoming instead a vast, mysterious pillar with a small cavern halfway up. Notice how textured the trunk is, with multiple crevasses and a big hole where the bark has been split and the interior of the tree is revealed. It's a very powerful experience of rugged surfaces and dark hollows.

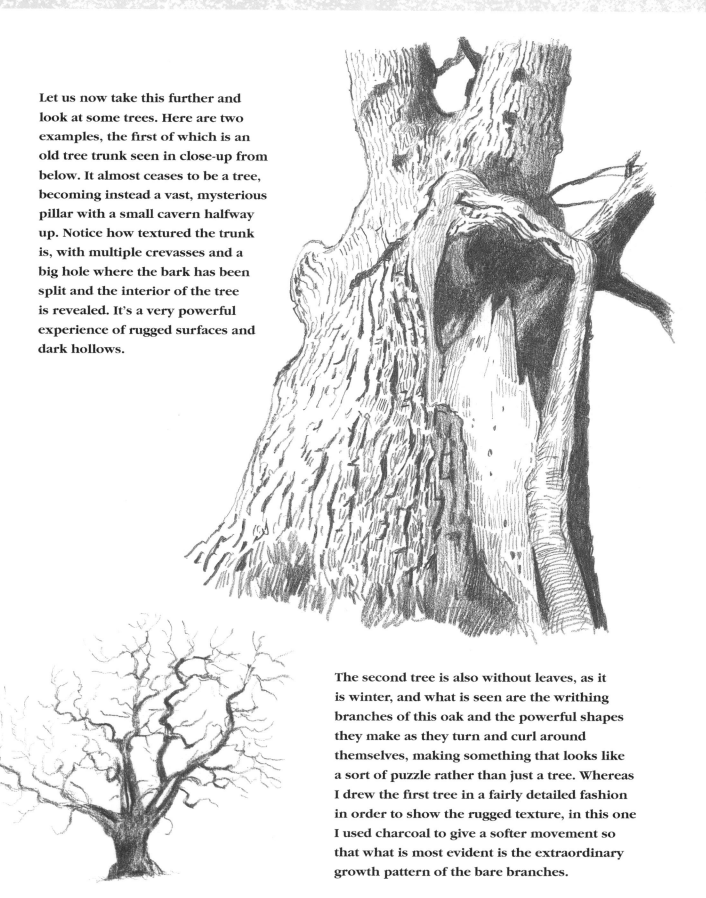

The second tree is also without leaves, as it is winter, and what is seen are the writhing branches of this oak and the powerful shapes they make as they turn and curl around themselves, making something that looks like a sort of puzzle rather than just a tree. Whereas I drew the first tree in a fairly detailed fashion in order to show the rugged texture, in this one I used charcoal to give a softer movement so that what is most evident is the extraordinary growth pattern of the bare branches.

FLOWERS AND HERBS

Plants are always a good subject to choose for practising your drawing, because they're living things that don't move too quickly, unlike most animals. What you'll notice, however, is that if you draw for any length of time you can observe their gentle movement. This is why it doesn't matter too much if the drawing isn't exactly like the plant, because it will never again look identical to your drawing, however accurate.

Flowers are particularly interesting to draw because they're very well defined in their shapes and delicate though vigorous in quality. When you tackle them you'll need to study them for a few minutes before you start in order to see exactly how their structure works. Approach them rather as a botanist might, being clear in your own mind as to the shape of what you're going to draw.

Here I show a few tulip blooms, which are very clearly shaped like a cup on a stem. They were near a window, so although the petals were a strong colour I could see the light shining through them.

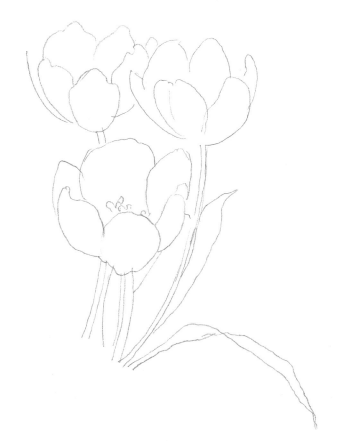

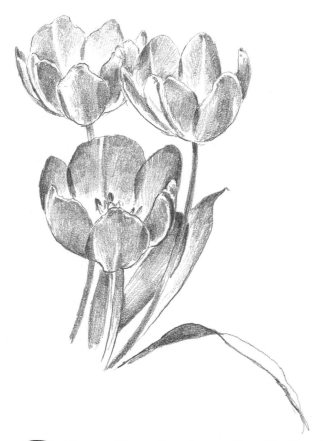

1 The first thing was to draw the basic cup shape of these flowers, standing erect on their stems. A couple of leaves growing off the stem helped to add to the picture.

2 Then, without drawing too heavily, I put in the tonal values, so that the light can be seen coming through the petals. When you try this drawing, don't overdo the tone or the tulips will start to look too solid and heavy. As the colour on the petals is in fine striations it's a good idea to draw your tonal lines in the same direction as the colour.

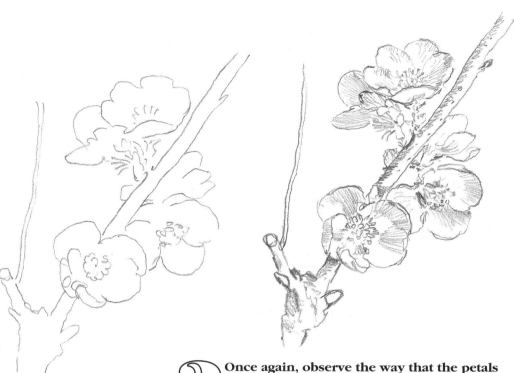

1 The next flowers I drew were from a japonica bush in my front garden. The branches of this bush are quite rigid and solid and the flowers seem to grow almost directly off them, juxtaposing strength and delicacy. The first thing was to map out the placing of the blooms on the branches. I have only drawn a few, but it's not difficult to draw many more as long as you observe the pattern of the growth.

2 Once again, observe the way that the petals are formed and draw the tonal areas in the direction of the growth of the petal.

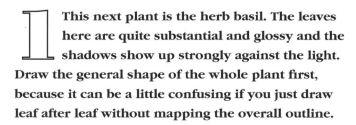

1 This next plant is the herb basil. The leaves here are quite substantial and glossy and the shadows show up strongly against the light. Draw the general shape of the whole plant first, because it can be a little confusing if you just draw leaf after leaf without mapping the overall outline.

2 Adding tonal values to the drawing can take some time because the forms of the leaves are very well defined. You don't have to be particularly cautious with the strength of the tone because the leaves are quite strong, with sharp edges. However, the stalks are rather translucent, so be more sparing with tone here.

WATER

Now we'll look at something in the natural world that's always fascinating for the artist, although not easy to draw: large expanses of water.

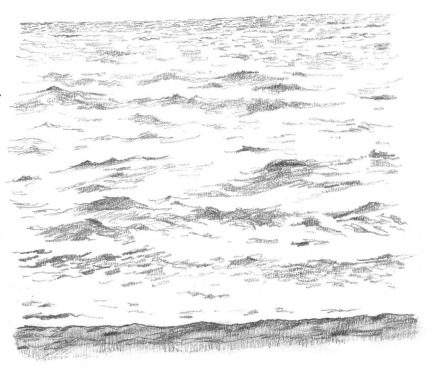

The first picture is a view of the sea with choppy-looking waves. To draw the sea you need a lot of patience, because of course it never stops moving. It's worth taking some photographs and then making a careful copy of one of them for practice before you try to draw from life. You need to keep making marks that give the same effect as the waves, but don't be too concerned if they don't all look exactly like the sea – just keep looking and drawing until you begin to get the feel of how the waves form and what you can see. Make sure that the waves closer to you are larger and further apart than the more distant ones; as your drawing gets to the horizon the waves are just tiny marks that create a texture of grey water in the distance. It's often a good idea to put a strip of the shore at the base of the picture to give the sense of where you are standing.

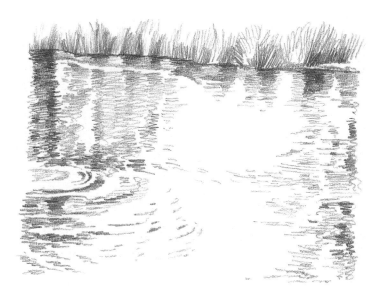

Water that's fairly still has large areas where nothing much is happening, making it an easier prospect. However, you will still have to be very careful and patient in making your drawing work well. In this drawing of a river, the bank in the background gives a hard edge to all the water. There's a large area of dark tone across one side of the drawing that is actually caused by a couple of trees on the far bank, though they're not visible here. The major ripples are caused by a couple of ducks that have swum out of view. When you're drawing ripples like this make the dark parts quite strong, with areas of white paper breaking them up. A succession of horizontal marks going backwards and forwards across the surface gives an effect of ripples in the water. You can leave a large area of untouched paper to give the effect of the sunlight lighting up the surface of the stream.

ANIMALS

While animals offer a rich vein of drawing opportunities they rarely keep still, so you'll have to be persistent in your efforts. I took the chance that our cat, who had curled up on a cushion, wasn't going to move unless someone disturbed him. Initially he seemed to be just a furry shape with a couple of ears poking out, but as I began to draw I saw more of the curves of his legs and body under the long fur and the patches of white fur acted as useful definition points.

To draw a cat moving I had to rely on my memory, and because I've observed them a lot it wasn't difficult to make a simple drawing of a cat playing with a ball of paper, tail held high. As I'd decided it was a black cat there was no detail to draw – just a dark silhouette, getting the movement as close as possible to how I remembered it.

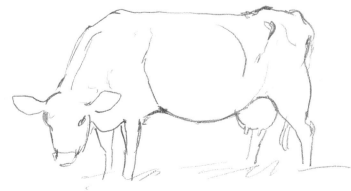

You may have a farm near you that opens to the public, which will give you an ideal opportunity to draw some domestic farm animals; otherwise you'll probably be able to find cows and sheep in fields not too far away. Of course the animals won't keep still, but they won't be moving about very rapidly unless they're alarmed. This gives you a chance to sketch some quick drawings. Sometimes just watch the animals closely without drawing, and notice how they move repeatedly into the same positions – unlike humans, or indeed cats, they are not mobile in an extravagant way. When you have observed them for a while, start drawing and try to catch them in the positions they seem to favour most. As you can see, I tend to achieve lots of bits and pieces instead of detailed drawings.

● HUMAN MODELS

When you're drawing human figures you'll need to keep your wits about you to avoid producing a series of conventional drawings that don't really express the full interest of which the human form is capable. So before you start, I want to show you a few things that should help to make your work more effective.

Here are two arms, one male and one female. They both belong to people who, although fully grown, are still young. Notice how the man's arm is muscular, with the definition of the muscles showing very clearly. When you look at the woman's you'll notice at once how much less the muscles disturb the smooth line of the arm.

Women generally have a much softer, more fluid look than men because of the thicker layer of fat under the skin, while a man's muscle and bone structure is usually more obvious. However, this doesn't necessarily apply to very young or very old people. As before, observation is key.

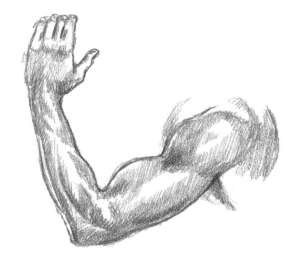

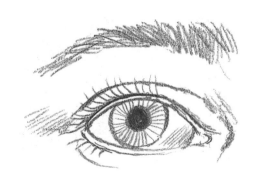

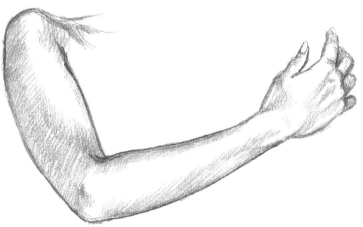

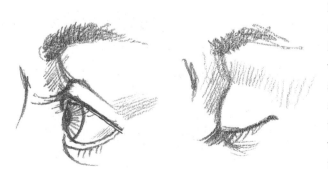

Now let's look at some facial details. In the drawing of an eye above left, notice the way that the upper and lower lids are formed and how the iris and pupil take up quite a bit of the white area of the eyeball. If the pupil and iris aren't shown slightly hidden beneath the upper eyelid the eye will look staring and a bit wild, while if the edge of the iris doesn't touch the lower lid the eyes will look a bit tired. In the side view, you can see that the ball of the eye bulges between the eyelids and when the eye is closed there is obviously a rounded shape under the lid.

Now look at the mouth. The strongest line is where the lips meet, not, as many novices draw it, at the outside edge of the lips – although lipstick will strengthen this. The lower lip is usually in more light than the upper lip, so the upper lip will look darker; the shadow on the lower lip is under the edge of the lip.

Seen from the side, the mouth is still defined by the place where the lips part and usually the lower lip is less protruding than the upper lip. When the mouth is open it's obvious why the meeting point of the lips is the most definite line in the mouth.

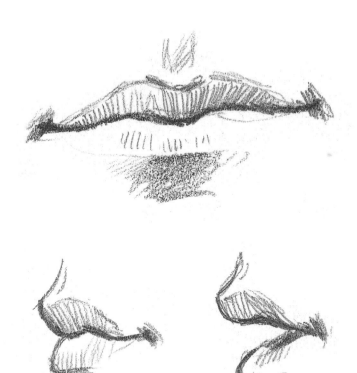

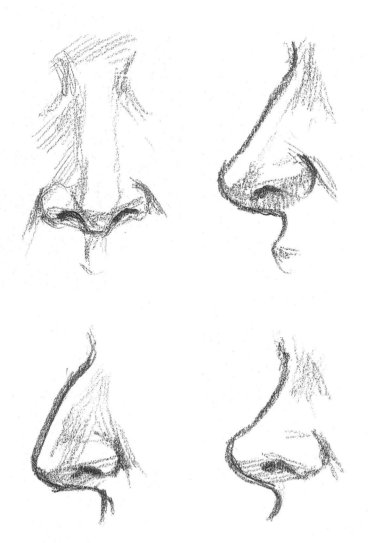

The view of the nose from the front is much less definite than the view from the side. This is why most portrait drawings show a three-quarter view of the head, so that the shape of the nose can be seen more clearly without losing one of the eyes. When drawing the nose from the front you have to rely on the shadows around the nostrils to show it clearly.

Seen from the side, the nose is quite easy to draw but beware of making it too big, too long or too short. There are basically three types of nose, although there are many variants on them: the straight nose, the bony or hooked nose, sometimes called aquiline, and the retroussé or snub nose.

CHILDREN

Children's heads don't match the proportions of an adult head. The greatest difference is the size of the cranium in relation to the lower jaw, but also the eyes are more widely spaced than in an adult and the cheeks are usually rounder. All the features fit into a much smaller space, and of course there are hardly any lines on the face.

These drawings of a little girl of four or five years of age, viewed from above and below, show the soft rounded cheeks and small snub nose which are fairly typical of the age group.

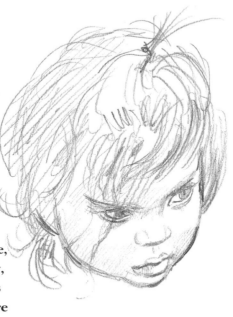

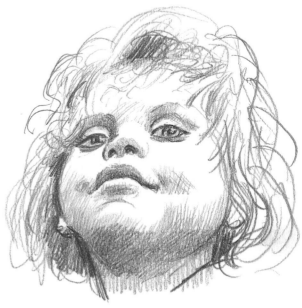

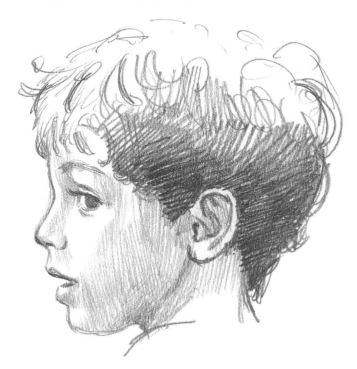

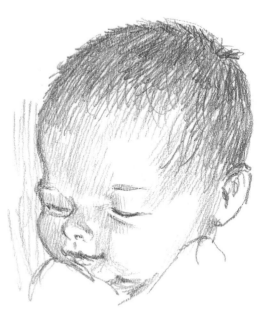

The little boy is a bit older but doesn't have a fully grown jaw yet, and his eyes and ears look much larger in relation to his nose and mouth than they would in an adult.

The little baby is an even more extreme shape, having a much larger cranium than face, with all her features being close together in the lower part of her head.

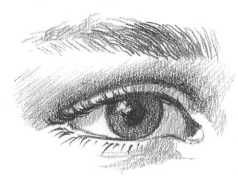

AGEING

Now let's look at the effect of age on the eye. This is quite important, because it's the eyes that mainly give us the clues as to how old someone might be. The first eye is of a little boy of six and looks as big and lustrous as any young woman's might. There are hardly any lines around the eye.

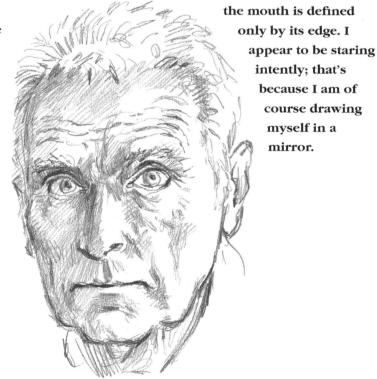

Finally, before we leave heads, I want to show you one of a young woman at her peak and one of an old man – my youngest daughter and myself. See the difference in the quality of the hair, on the one soft and shiny, the other white and sparse. Then look at the surface of the skin. Although my daughter is grinning widely she has very few lines on her face and her eyes are very clear. My own skin is furrowed with lines of all kinds, especially around the eyes and on the forehead. The cheeks look more hollow and the mouth is defined only by its edge. I appear to be staring intently; that's because I am of course drawing myself in a mirror.

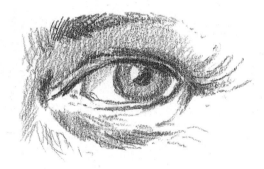

Next we have someone of middle age. Although the eye is still quite lustrous there are lines around the eye socket that give you some idea of the age.

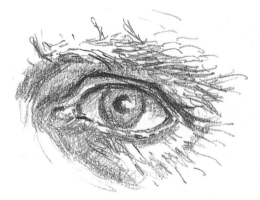

This is the eye of an elderly person, with all the multifarious lines etched into the skin and the straggly eyebrows.

PUTTING FIGURES TOGETHER

One of the greatest problems for an artist is designing a picture so that it looks natural rather than posed. With observation, you'll begin to realize that when several people are together their bodies relate to each other in certain ways. We'll be looking at figure composition in more depth later in the book (see pages 98–105), but for now we'll just concentrate on observing how people appear when they are in groups.

In the first drawing I've put together a group of young people such as you might find at a party, where some figures obscure your view of others farther away. In the foreground is the head of a girl who might be listening to someone that we can't see and immediately behind are a couple who seem to have just arrived, a young man looking towards the girl in the foreground, a couple who might be dancing, and in the distance another girl just glimpsed. This is a relatively tight composition, with enough balance and tension between the characters to suggest a real scene.

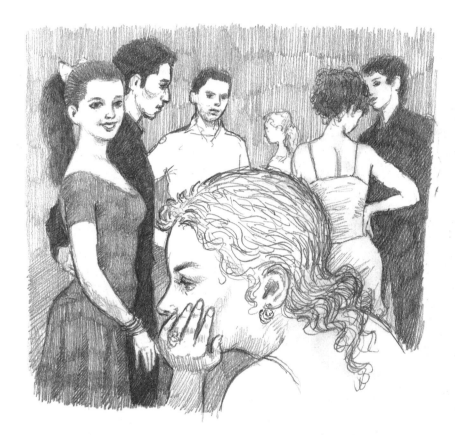

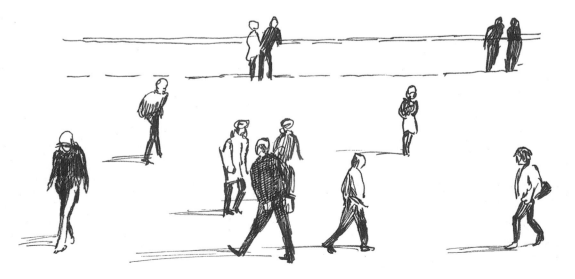

Next is a group of people who have very little to do with each other, except that they're all in the same street and on their way somewhere. Notice the staggered formation where one figure is walking past another. In this typical street scene, the spaces are just as important as the figures.

● BUILDINGS

This drawing of a French cathedral is a fairly simple example of how much you can leave out when tackling large buildings. Some knowledge of perspective is useful, but it's possible to draw quite accurately without it. This is why observation is so important for an artist, because even without theoretical knowledge anything can be drawn with conviction.

Here the point is not to try to include every detail but to draw in the main shapes first and then, after checking that the proportions look good, show the main areas of dark tone where the building is recessed, such as the windows. The architectural detail can be put in with small marks that resemble the look of the construction, without being correct in detail; as you can see from this drawing, it's still possible to get a good idea of what the cathedral looks like.

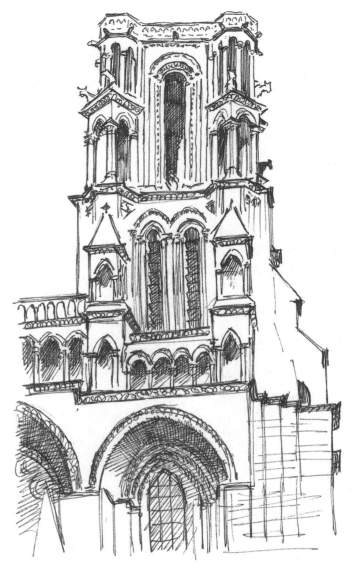

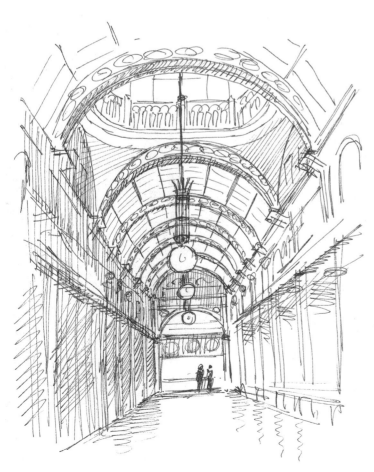

The interior of a large building such as this arcade is a difficult subject, but with careful consideration of the main shape of the area to be drawn it shouldn't be beyond your capabilities. A little knowledge of perspective is of course very useful here (see pages 78–89), but even without it you can hold up your pen or pencil horizontally and then tilt it until it resembles the angle of the main lines of the building. This will give you quite a lot of information as to how you are going to draw it. Where there is a lot of decorative ironwork, don't try to get it all correct in detail, just draw it as inspired scribble – that is, just make shapes that give a similar effect to the masses of ornament, as I've done.

CHAPTER 5
PROPORTIONS AND PERSPECTIVE

In this section we shall look at some of the classic rules of drawing: the proportions of the human head and body, and how to build one, two and three-point perspective. These are useful guidelines for any artist, and learning them will help to inform your drawings and make them more accurate.

● PROPORTIONS OF THE HEAD

PROFILE VIEW

This view of the head can be seen proportionately as a square which encompasses the whole head. When this square is divided across the diagonal, it can be seen immediately that the mass of the hair area is in the top part of the diagonal and takes up almost all the space, except for the ears.

When the square is divided in half horizontally it's also clear that the eyes are halfway down the length of the head. Where the horizontal halfway line meets the diagonal halfway line is the centre of the square. The ears appear to be at this centre point, but just behind the vertical centre line.

A line level with the eyebrow also marks the top edge of the ear. The bottom edge of the ear is level with the end of the nose, which is halfway between the eyebrow and the chin. The bottom edge of the lower lip is about halfway between the end of the nose and the chin.

While these measurements aren't exact, they are fairly accurate and will hold good for most people's heads.

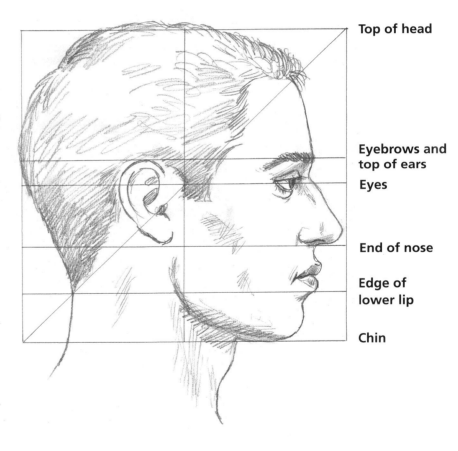

Top of head

Eyebrows and top of ears

Eyes

End of nose

Edge of lower lip

Chin

FRONT VIEW

From the front, as long as the head isn't tilted, it is about one and a half times as long as it is wide. The widest part is just above the ears.

As in the side view, the eyes are halfway down the length of the head and the end of the nose is halfway between the eyebrows and the chin; the bottom edge of the lip is about halfway between the end of the nose and the chin.

The space between the eyes is the same as the length of the eye. The width of the mouth is such that the corners appear to be the same distance apart as the pupils of the eyes, when looking straight ahead.

These are very simple measurements and might not be quite accurate on some heads, but as a rule you can rely on them – artists have been doing so for many centuries.

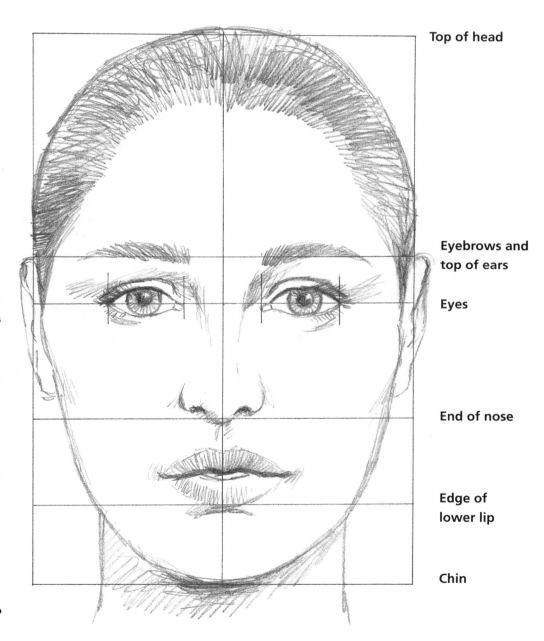

Top of head

Eyebrows and top of ears

Eyes

End of nose

Edge of lower lip

Chin

● PROPORTIONS OF THE BODY

Familiarity with the proportions of the body will help you to make your drawings more convincing. Here we look at three versions of the human body standing upright, a male full front, a male side view and a female full front.

FRONT AND SIDE VIEW OF THE BODY

If you take the length of the head as the unit of measurement, the whole length of the body is equivalent to about seven and a half heads. This is true of both male and female bodies – although the female is usually slightly smaller, the proportions remain the same.

The level of the nipples is about two units down from the top of the head, while the navel is three units down. The top of the legs is about four units down; the length of the arms and hands, with the fingers extended, comes down four and a half units, to the middle of the thigh. The bottom of the kneebone appears about five and a half units down from the top.

The main difference in proportion between the male and female comes in the width of the hips and the shoulders. The shoulders are usually the widest part of a man's body while the hips tend to be the widest part of a woman's.

These proportions act as guidelines when you are drawing the human form, but even so nothing beats careful observation. Remember too that people differ in the bulk of flesh and muscle, and although the female form is usually rounder and smoother you may find exceptions. However, these proportions apply to almost all people of adult years. Children, of course, are of different proportions at different ages.

MALE

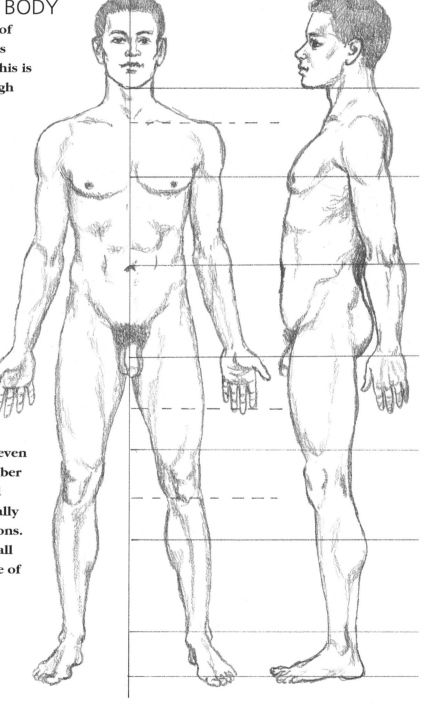

PROPORTIONS THE SAME ALTHOUGH HEIGHTS MAY BE DIFFERENT

FEMALE		HEAD UNIT
	Top of head	0
	Chin	1
SHOULDER LINE		
	Nipples	2
	Navel	3
	Pubis	4
LENGTH OF ARM AND HAND		
	Above knee	5
BOTTOM OF KNEEBONE		
	Mid-calf	6
	Ankles	7
		7½

● PROPORTIONS IN A PERSPECTIVE VIEW

We rarely see the body so neatly arranged as in our diagrams of proportion; we mainly view people from all sorts of angles, often with their limbs foreshortened. The following illustrations show some proportions that commonly occur.

Here is someone lying down, seen from the feet end. Because they are closest to the viewer, the feet will appear much larger than we would usually expect. Here the length of the foot is almost as long as the head and torso of the figure.

The legs from the ankle to the hips are the main area of the body on show, appearing more than twice as large as the head and torso. The legs and hips are also much thicker than the upper parts of the figure.

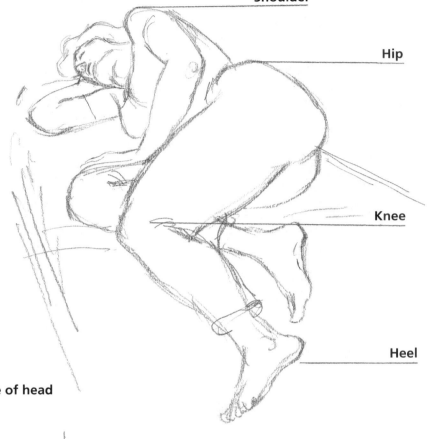

Shoulder

Hip

Knee

Heel

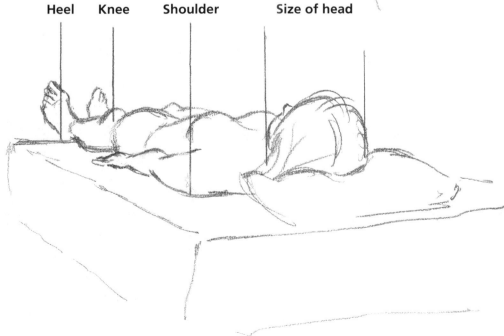

Heel Knee Shoulder Size of head

When we view a figure from the head end, the head and shoulders appear to dwarf the rest of the body. The feet are less than half the size of the head. Everything diminishes as the body recedes from us.

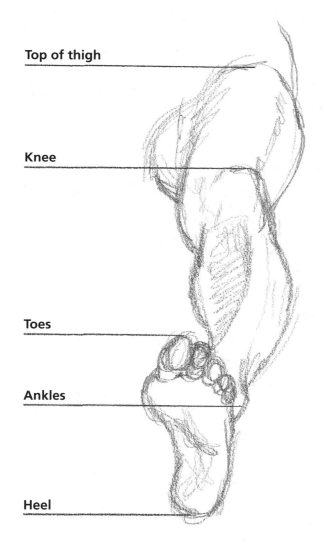

Top of thigh

Knee

Toes

Ankles

Heel

Looking from the foot, it appears almost as long as the whole of the leg, although we know that's not the case. The knee seems to be much further up the leg than we would expect. The thigh is diminished in contrast to the lower leg.

On the arm the same thing occurs; when we're looking from the hand, the shoulder, upper arm and lower arm appear to be no longer than the hand. In this extreme view, the main length of the arm has been reduced to almost nothing, while the hand appears to be enormously enlarged.

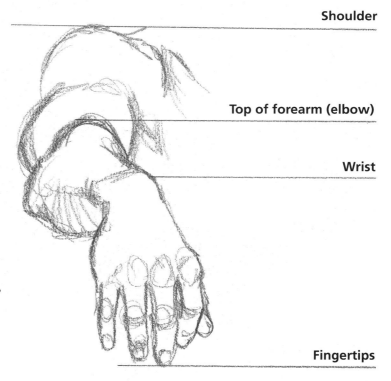

Shoulder

Top of forearm (elbow)

Wrist

Fingertips

77

● ONE-POINT PERSPECTIVE

One-point perspective is the simplest form of perspective and often the only one you need to know when you're drawing subjects from close quarters.

To start a one-point perspective drawing, for example of a room, you first need to establish a horizon line, or eye level. Perpendicular to that, near the middle of the horizon, a vertical line represents your viewing point. Then, to construct the room, you need a rectangle with the two lines crossing near the centre of it – don't place them exactly in the middle, or it will look a bit too contrived. Now draw lines from the centre point where the horizon and vertical meet to pass through the corners of your rectangle.

From this point you can now construct lines as shown, to place the position of a door on one side wall and two windows on the opposite wall.

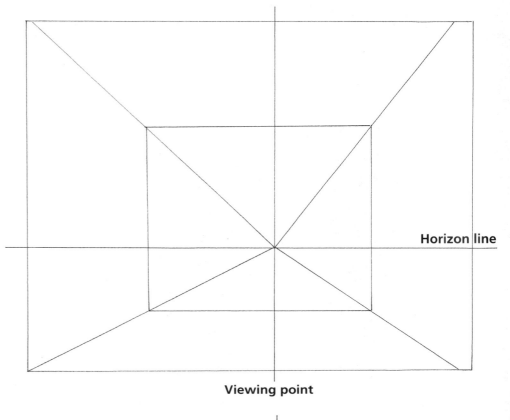

Horizon line

Viewing point

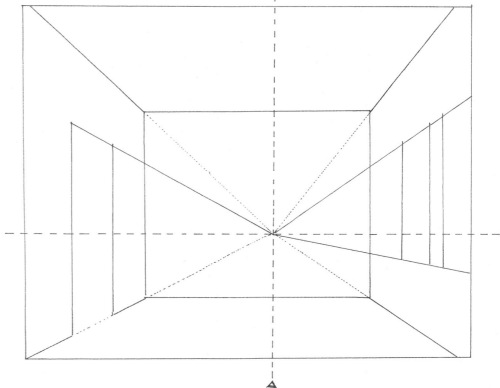

If you imagine yourself in an empty room, standing not quite in the middle, you might see something like this diagram, based on the perspective lines you've just established. Here there's a low eye level, which must mean that you're sitting down, and the room has a door to your left and two windows to your right. It has bare floorboards and strip lighting on the ceiling. There's a large picture frame hanging on the far wall.

Notice how the vertical line indicates your viewing position and the horizontal one your eye level. All the floorboards seem to slope towards the centre point, known as the vanishing point. The lines of the skirting boards and the cornice rail on the walls to each side all slope towards this centre point also, as do the tops and bottoms of the door and the windows. In other words, except for the lines which are vertical or horizontal, all lines slope towards the centre point – which is why it is called one-point perspective.

This diagram gives a good idea of how you can set about constructing a room that appears to have depth and space. Now go and stand or sit in a room of your home and see if you can envisage where imaginary horizontal and vertical lines representing your eye level and viewing position cross; this is the vanishing point for the perspective, to which all the lines that aren't vertical or horizontal will slope. Even the furniture is included in this as long as it's square on to the outlines of the room.

Here's a vast interior of an old medieval church that shows how one-point perspective works, even with an unusual building such as this. I've purposely left out any furniture in the drawing so that you can see where the perspective lines of the roof, windows and columns all join at one point, showing our eye level and viewing point.

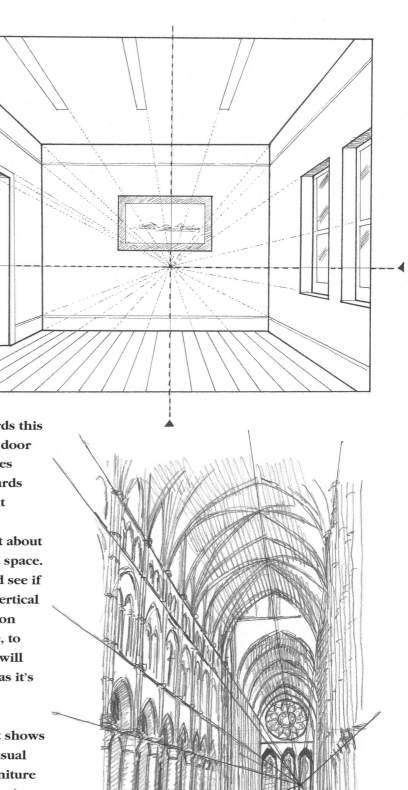

● TWO-POINT PERSPECTIVE

When you draw outdoors you need an extra measure of perspective, because you're dealing with much bigger spaces and with large objects such as buildings and cars. This means that you need to use two-point perspective, which will enable you to construct buildings that look convincing.

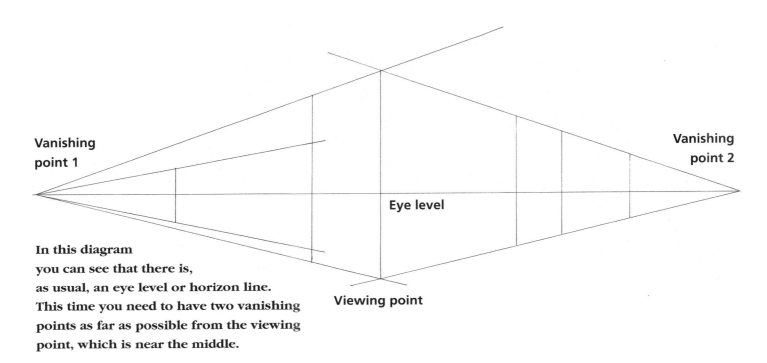

Vanishing point 1

Vanishing point 2

Eye level

Viewing point

In this diagram
you can see that there is,
as usual, an eye level or horizon line.
This time you need to have two vanishing
points as far as possible from the viewing
point, which is near the middle.

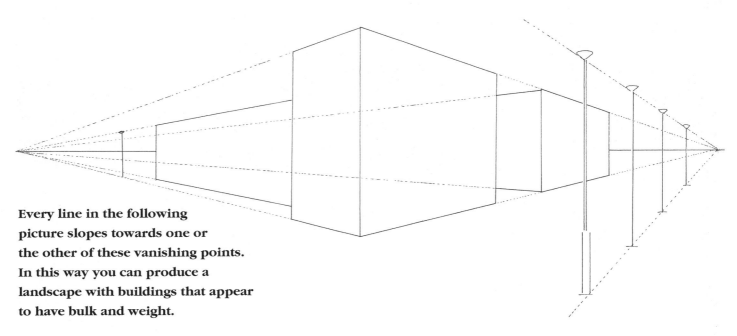

Every line in the following
picture slopes towards one or
the other of these vanishing points.
In this way you can produce a
landscape with buildings that appear
to have bulk and weight.

Notice how the lamp-posts appear to become smaller as they recede from your point of view. The tops and bottoms of the posts are in line, and all the rooflines of the buildings can be joined in straight lines to one of the vanishing points. The same applies to all the windows, doorways and pavements. The corner of the nearest building is on the viewing vertical and all the other parts of the buildings appear to diminish as they recede from this point.

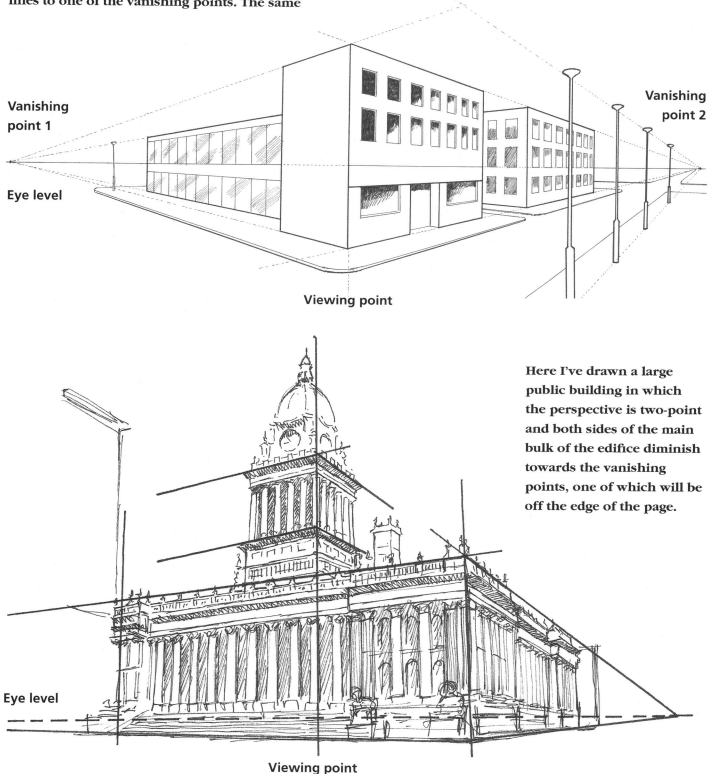

Vanishing point 1

Vanishing point 2

Eye level

Viewing point

Here I've drawn a large public building in which the perspective is two-point and both sides of the main bulk of the edifice diminish towards the vanishing points, one of which will be off the edge of the page.

Eye level

Viewing point

THREE-POINT PERSPECTIVE

While one-point and two-point perspective are generally all you'll need, when you start to draw very tall buildings you may have to bring in a third point of perspective.

This enormous cathedral at Reims in France is a case for three-point perspective. Because of the great height of the building and the fact that the viewpoint is so close a third vanishing point is needed high up in the sky above the cathedral. All the vertically sloping lines along the sides of the building must eventually meet at a point somewhere above it that's off the paper.

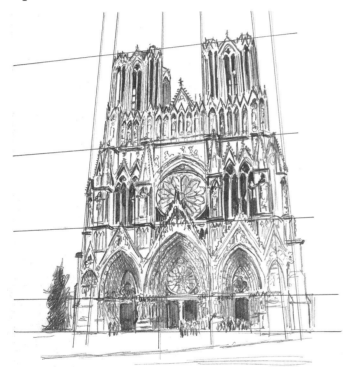

A very high vanishing point is of course much harder to judge, as there is nothing on which to fix your point. But you can see the way it would work, and if you ever have to draw a skyscraper from close to, you would have to use this method to make sense of it.

● APPLYING PERSPECTIVE

Next we'll look at how you can apply perspective when drawing landscapes. There follow three views of the same scene along a road, each view taking you nearer to a bird sanctuary observation post.

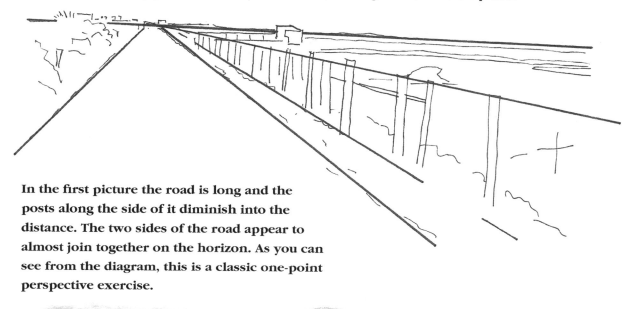

In the first picture the road is long and the posts along the side of it diminish into the distance. The two sides of the road appear to almost join together on the horizon. As you can see from the diagram, this is a classic one-point perspective exercise.

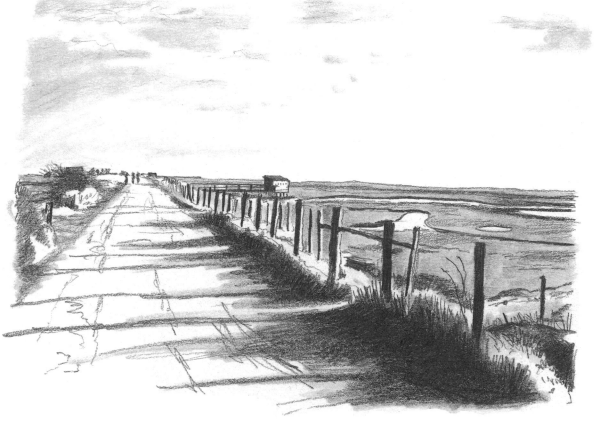

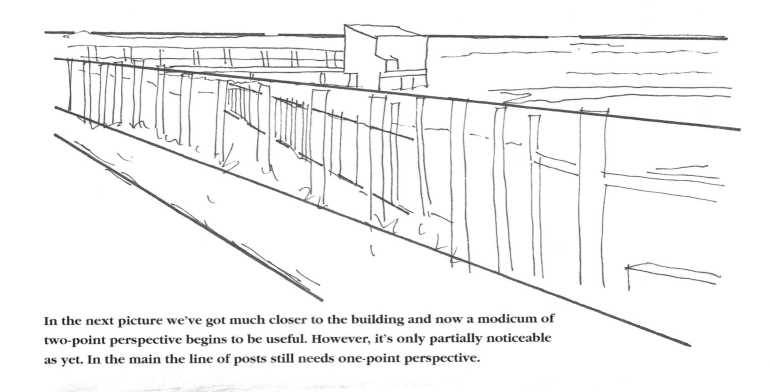

In the next picture we've got much closer to the building and now a modicum of two-point perspective begins to be useful. However, it's only partially noticeable as yet. In the main the line of posts still needs one-point perspective.

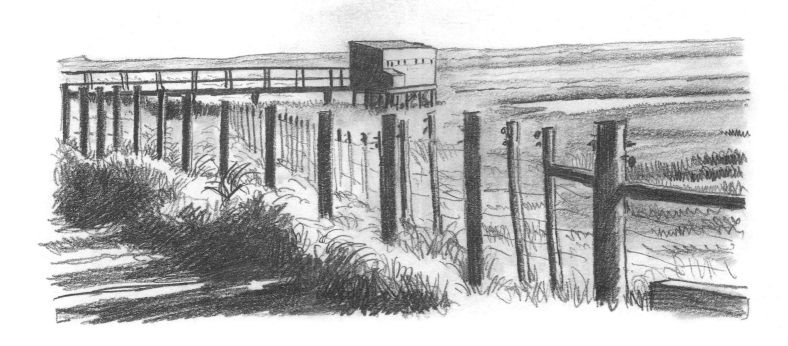

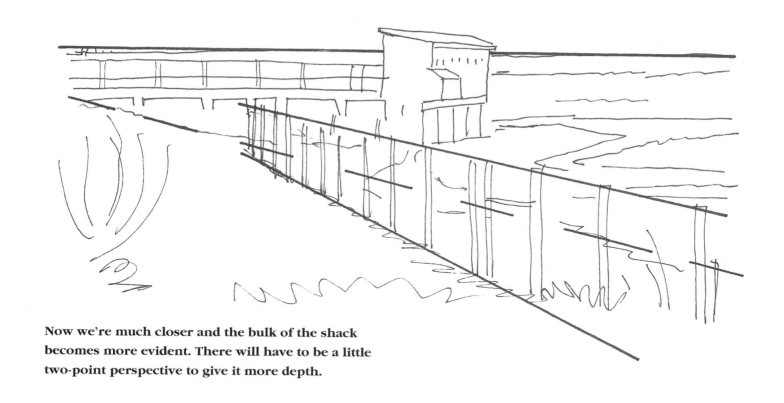

Now we're much closer and the bulk of the shack becomes more evident. There will have to be a little two-point perspective to give it more depth.

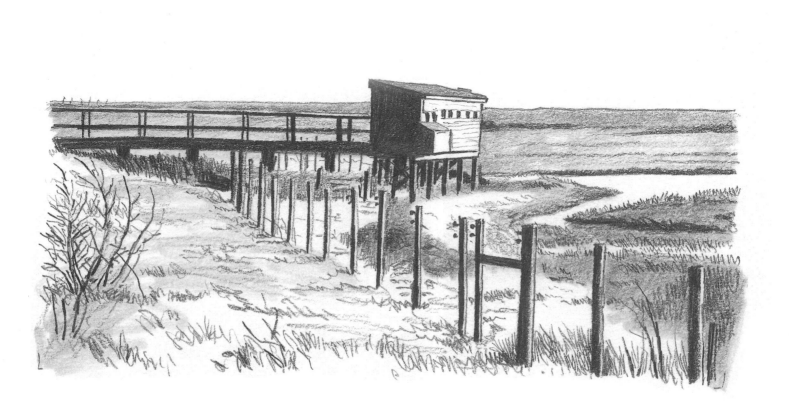

Here are two scenes in which it's easy to see how the effect of perspective is making itself felt in the drawing of objects that are set at different distances from us but are all of similar shape and form.

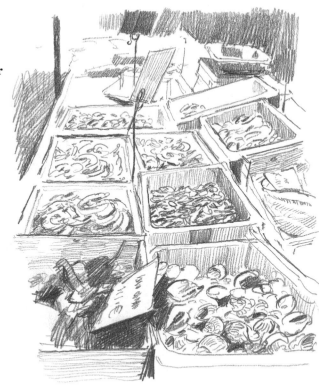

Perspective is used not just on the table but on all the boxes of fish and shellfish lined up in a French marketplace.

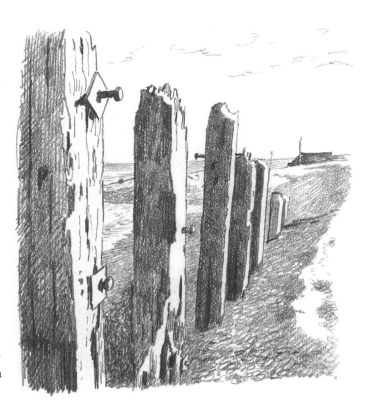

Even in a short row of breakwater posts, the recession from our viewpoint gives a strong sense of depth to the beach scene.

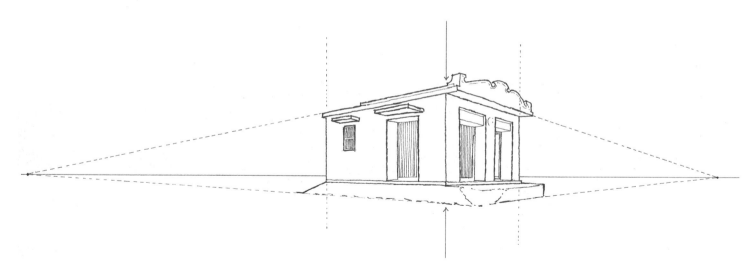

Now we look at a series of drawings which show how two-point perspective will help you to draw buildings more convincingly. It's most useful with architecture, although if you draw a still life large enough it can come into play there too.

This simple structure in India has been covered with painted advertisements. You can see the horizon line behind the building and the lines of perspective drawn from the highest and lowest points at the viewpoint edge. The viewpoint at is the nearest corner of the building. The two main lines of perspective from these points are drawn to the two vanishing points at either end of the horizon line. All the lines parallel with these two sides of the building should arrive at one of these two vanishing points. The other lines are all perpendicular to the horizon.

As you can see from the sketch beside the more finished drawing, the method is quite simple. In the case of this drawing, one of the vanishing points is closer to the viewpoint vertical than the other, which means that you can see a bit more of the side of the building than you can the front.

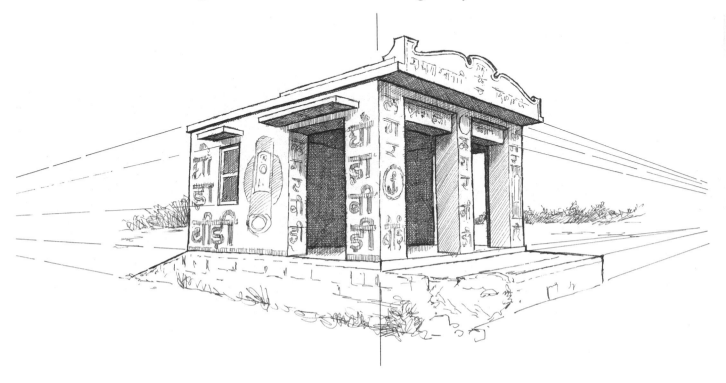

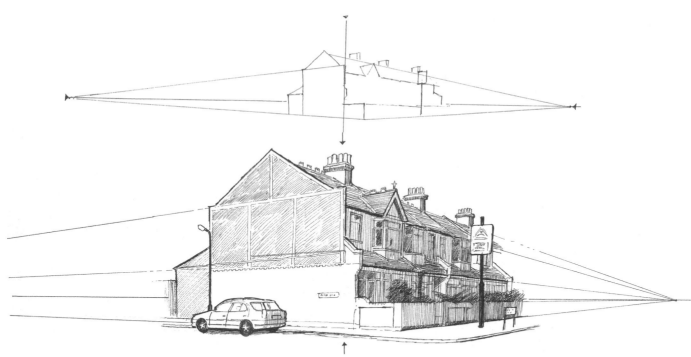

The next drawing is more complex, because it's of a block of suburban houses on the corner of a street and there are more details of the buildings to consider. But don't feel hesitant about tackling this because at the angle it's drawn a lot of the detail can be just suggested, with marks that aren't precise. The main bulk of the building is the critical part and if you get that right, the rest will look right too.

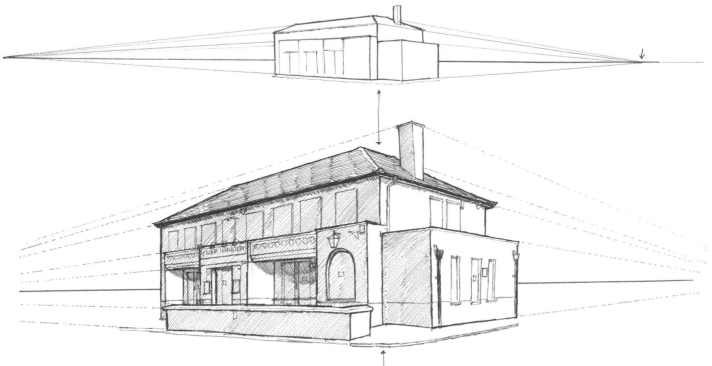

In the next drawing, of a boarded-up public house, the bulk of the building is fairly simple and there isn't much detail to get caught up in. Once again there are two vanishing points and the viewing point is the corner of the building nearest to the viewer.

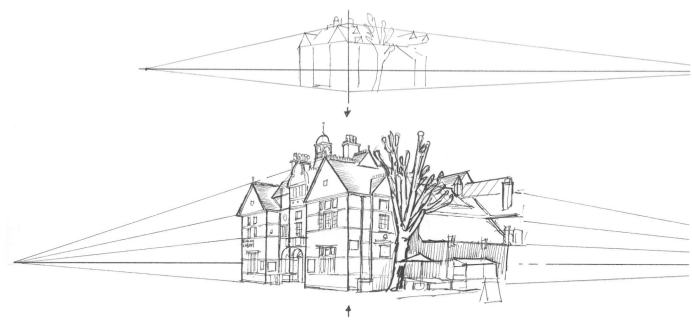

Now a complex building – a Victorian library that has a lot of detail in the construction. But the same rules still apply, and when you come to draw something like this don't be daunted – just remember the rules and adjust the drawing to your own impression of the building. You should never be too rigid about perspective unless you are drawing for an architect or engineer.

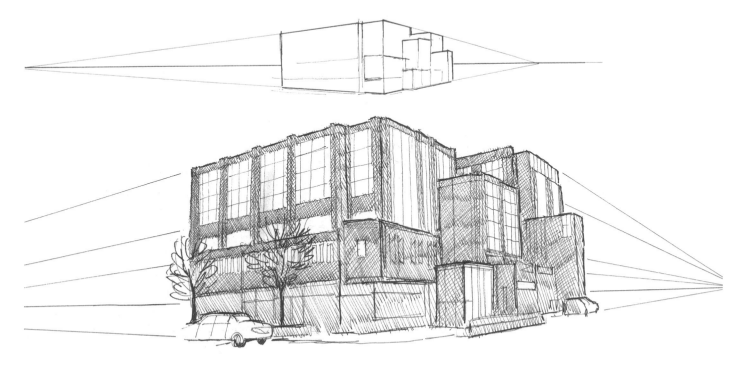

Here's an example of a modern structure on the corner of a high street, built in clearly defined blocks and with a lot of window space. Like the first drawing of the very simple building (on page 87), this shows clearly how the rules of perspective can work to convey the bulk of the building.

CHAPTER 6
COMPOSITION

When it comes to composing pictures, there are no hard and fast rules that you have to follow. Generally speaking, the main thing to concern yourself with is the effect you wish to create with a picture; you may want it to be dramatic, for example, or tranquil. But here are a few ideas about composition that will give you a starting point from which you can then go ahead and devise your own ways of working.

● COMPOSITION DIAGRAMS

In the first diagram I have just divided the space into quarters, with one horizontal line halfway down and one vertical line halfway along. So if you place your main subjects at the centre of your page and try to balance out all the various parts of the drawing, you will arrive at a simple centrally placed image.

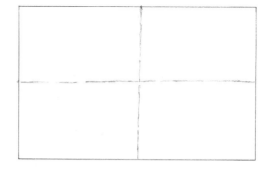

A centrally based composition with a raised horizon line will give you the effect of distance and of looking across a space from a higher position. This can help when producing a large open landscape.

The next diagram shows how tilting this axis of lines and moving the crossing point over to one side gives a different balance of marks, which will be more dynamic and possibly dramatic. This slightly off-balance design is similar to many of the Impressionists' compositions, which they in turn derived from Japanese prints.

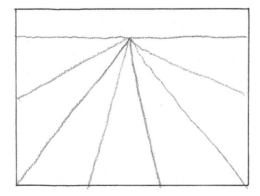

This diagram shows a more abstract design, with a spiralling inward effect caused by placing solid shapes in ever-decreasing sizes into the centre. If you are drawing numbers of people you might want to take an approach like this.

A composition such as this is useful for landscapes and figure groups, because it starts with something close to the viewer on one side and gradually sweeps away to a distant eye level at the opposite side. The obvious example of this could be a street scene with the buildings diminishing into the distance.

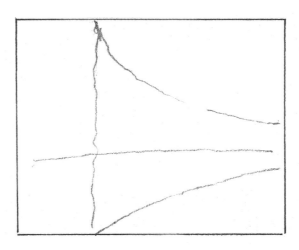

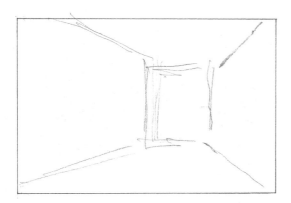

When you are working on an interior space decide at the start where the far wall or end of the space will be placed. Here I've put it to the right of the scene about in the middle horizontally. But the main thing is to make the decision before you start.

Using a triangular shape of figures in a picture can make a very stable composition, and yet still be with motion.

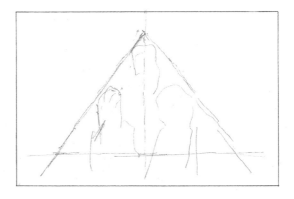

● COMPOSITION BY MASTER ARTISTS

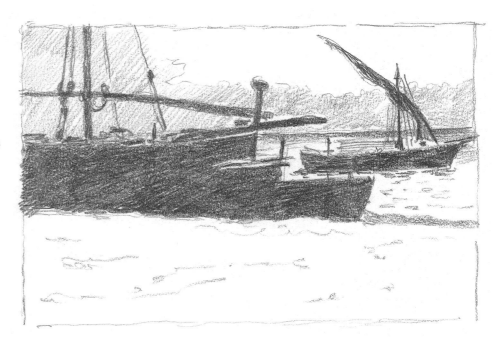

Here are some compositions by the American painter John Singer Sargent. The first is of a seascape with a large fishing boat drawn up on the beach and, beyond that, another vessel floating on the water. The dark, closer boat makes a solid wedge of tone stretching halfway across the scene, and the beach and sky take up most of the rest of the space. The second vessel is squeezed into the small area of water that can be seen past the beach and nearer boat. You gain a strong sense of what the scene must have been like when Sargent saw it. He obviously decided that he wouldn't include all of the closer boat, using it instead as a sort of frame for the vessel floating beyond. The light seems to indicate that this dramatic scene is either late or very early in the day.

This scene, again by Sargent, is of a beach in Morocco with fishing nets spread out along the length of the beach. He has used a strong diagonal composition, with the beach taking up half the picture and the line of nets and the waterline emphasizing the diagonal. Up in the top half the rocky shore juts into the rest of the picture, and the deep blue sky and sea contrast strongly with the white sandy beach. It's an unusual compositional device, but in his hands one that works very well.

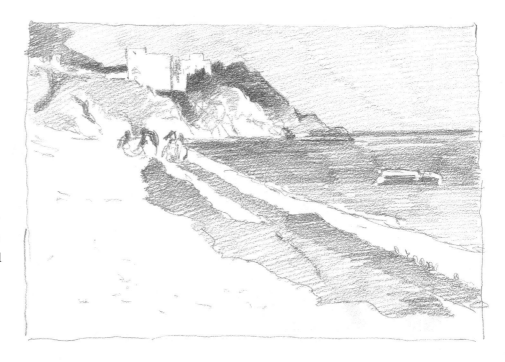

The next examples each have a small diagram to bring home the point of the composition. When you first look at a picture, it's sometimes easy to miss interesting compositions because there's so much to take in. In each of these examples the artist has made a decision to include some things and omit others in order to improve his picture.

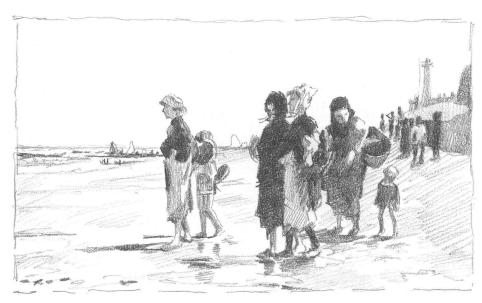

The first one is by Sargent again, and it's another beach scene. However, this time there is human activity, with a group of fisherwomen walking across the scene towards the sea, probably to catch shellfish. The figures form the main part of the scene with, behind them, an open beach, a few figures in the distance and a lighthouse. There is a clear sense of the fisherwomen being distinct from any other activity. They are all going in the same direction from the right side of the composition towards the open left side. The figures are strong and dark against the light and there are reflections of them in the pools of water on the beach. Notice how Sargent uses the different sizes of the two children accompanying the women to balance the mass.

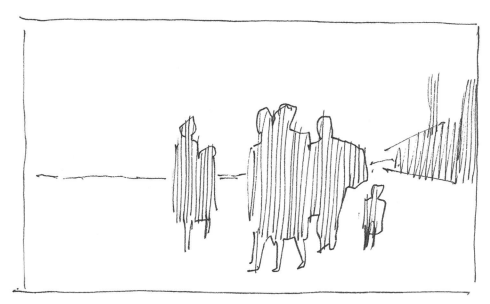

The diagram of the composition makes it very clear that the clump of figures is the main point of the scene and the rest is just background space.

In the next scene, by J.M.W. Turner, the main focus of interest is on the rugged castle at the edge of the sea. Turner uses the great sweep of dark clouds swirling around the sky in the background to almost frame the scene. He also gives you the close-up waves of the sea breaking on the near shore as a dramatic angle to pull your attention towards the distant castle. In terms of area the castle is quite small in the picture, but because of Turner's ability to compose the scene your eyes are drawn towards the building. He has placed it centrally, which helps, but it's remarkable how he has made the elements of the coastal scene emphasize the point of the picture.

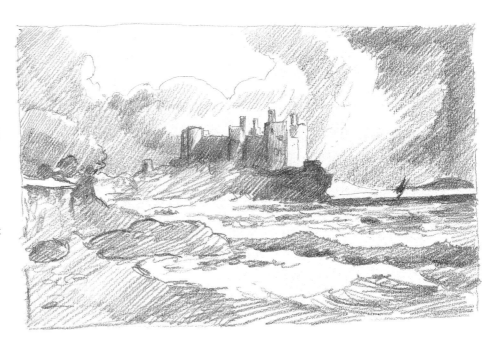

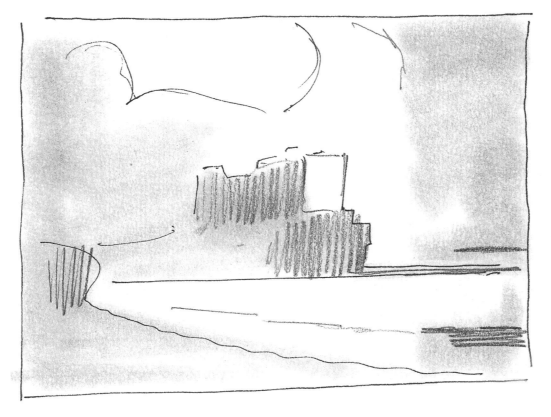

In the diagram you can see how small the area of the castle actually is, but the framing of it with the sky and sea brings our attention to where Turner wishes it to be.

Now we have a still life by Paul Cézanne of a couple of pots, a jug, some fruit and a cloth arranged on a table. He allows quite a lot of space around them and contrasts the white jug, pot and small cloth against the dark larger cloth, the fruit and the dark pot.

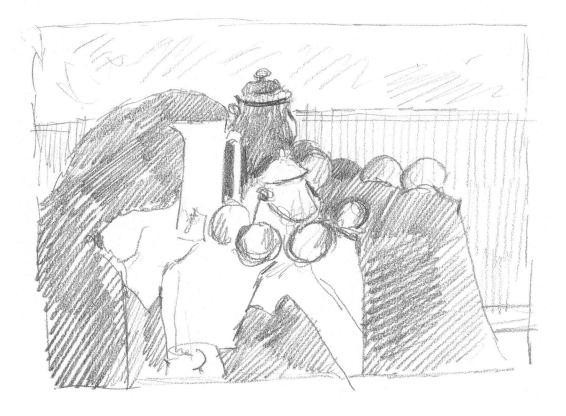

As you can see in the diagram, the white area is quite small, held in the middle of the dark mass of cloth, fruit and pot, which takes up about half the space, and the mid-toned background, which is almost as large. Consequently, the light objects attract our attention even though they take up quite a bit less space in the whole picture. This subtle understanding of composition is the reason why Cézanne is considered such a master.

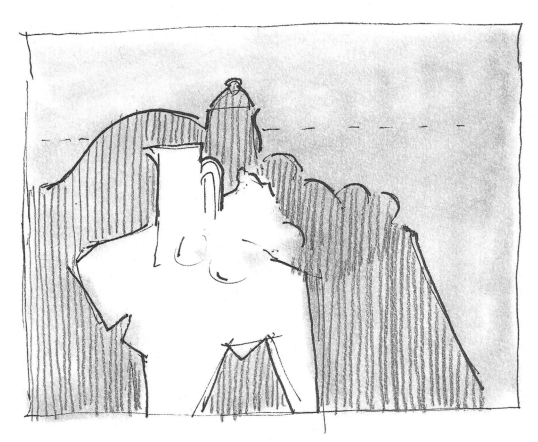

● MASS AND ISOLATION

In the two pictures on show next, I'm using examples of photographic compositions which work very well and could easily be used by an artist. They emphasize two different things – one the use of a large mass of details to make your point, and the other isolating one part of the scene to give it added emphasis.

The first picture is a close-up view of an ornate Russian Orthodox cathedral and is really a composite mass of decorative domes, towers, arches and doorways that seem to have been assembled almost indiscriminately. There is undoubtedly an architectural logic to the whole thing, but from our viewpoint we can't see this. What we can see is detail crowded upon detail, with just a bit of sky at the top to give us an idea of the architectural mass. The picture makes its point by being rich in detail and pushed up against our view so that it almost overwhelms us.

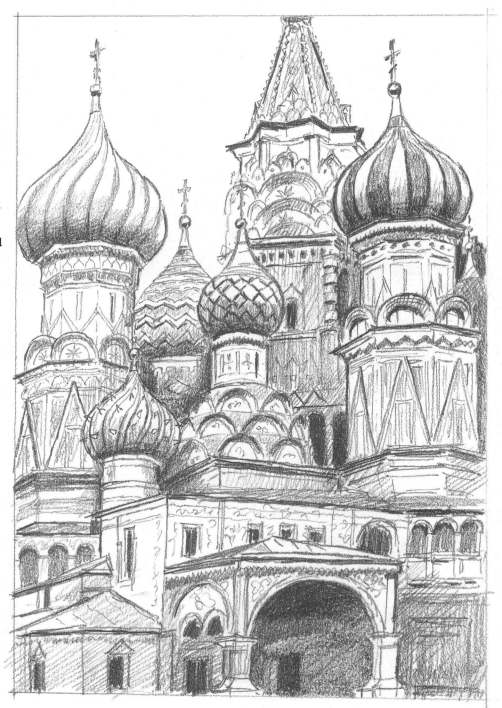

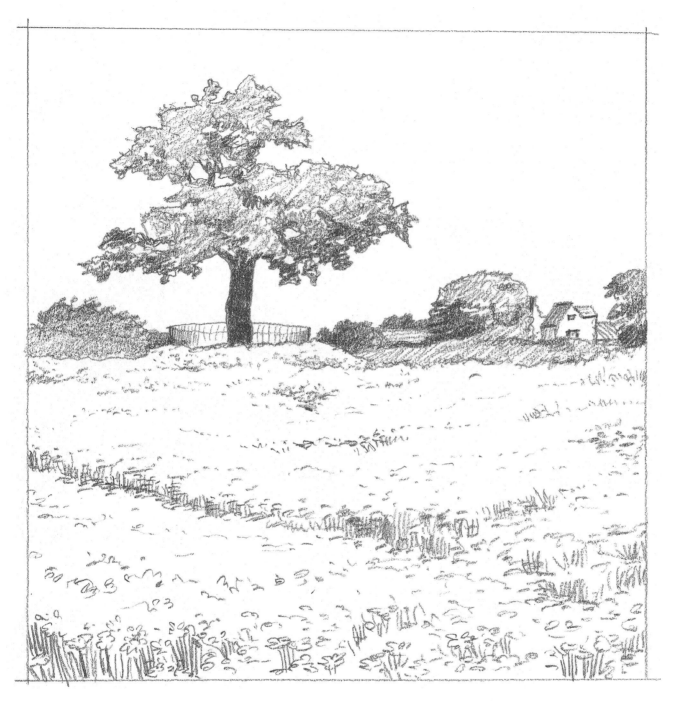

The second example is of an open meadow full of white flowers that creates a sort of carpet spreading away from our viewpoint and taking up half of the whole scene. Beyond this is the sky – we are obviously looking uphill – and a few indications of buildings and vegetation along the horizon. But at the centre-left of the upper half of the scene is a tree with a strong trunk and spreading branches.

Isolating this tree gives it a grandeur and an importance in the composition that makes us remember the scene as dominated by the tree. Its placing makes it definitely the focal point of the scene and nothing else has quite so much personality as this object, although the flower-strewn field was probably the first thing that caught the photographer's eye.

● FIGURE COMPOSITION

There are many ways to give a human figure a setting. Sometimes you'll want to bring in other elements to frame or give focus to the person, but whatever you do there'll be some compositional effect.

In this first example, the Renaissance artist Alesso Baldovinetti has taken a profile view of a young woman, probably a member of the nobility, and included her shoulders and chest. The delicacy of her face is set off by the elaborate hairstyle and the beautifully decorated sleeve of her dress. The face is treated with simplicity, and the main detailing is in the hair and the dress. The whole thing becomes a beautiful design with the personality of the sitter kept very unemphatic.

This is a drawing from the end of the 19th century, with a portrait of a young and fashionable woman seen through a mesh of leaves on stalks overlaying the foreground. The leaves frame the face and upper body of the woman and, because she is looking down at a book, her personality isn't as important as the decorative impact of the composition. This was drawn for the cover of a magazine, so the effect had to be charming and the portrait was not important as such.

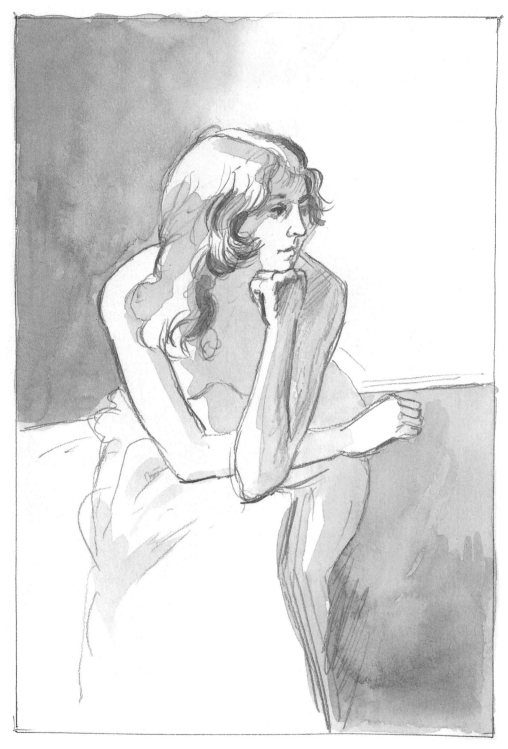

The third drawing is by the British artist John Ward, who has portrayed a young
woman sitting with her chin supported by her hand as she gazes into the distance.
Most of the space around her is empty and she seems to be wrapped in a sheet.
Here again, the personality of the sitter doesn't seem to be the point of the picture;
rather the meditative quality of her pose seems to be the important thing.

The next example, by the great Renaissance painter Sandro Botticelli, is of a youth who is just looking straight out of the picture. He appears to be deep in thought, and although he is obviously accurately drawn he seems to be an example of youthful dreaming rather than a character in his own right. It's interesting that the artist has placed him so that all you see is his head and shoulders, with no particulars of clothing and no clues as to who he might be.

This picture is quite different in that the figure stretched out on an old sofa is a young, tough-looking airman in old-fashioned overalls and leather flying helmet, smoking a cigarette. Behind him is a battered interior wall with a picture of an American fighter aircraft of Second World War vintage. The picture makes its point that the airman is relaxing but ready to go out to fly, with the large expanse of wall above him and the small photograph or painting of an aircraft, possibly like the one he will pilot. There is much characterization in the pose of the man and the rather down-at-heel room he is resting in.

The next picture has more of a fashion feel about it, showing a young woman elaborately dressed in the style of the early 20th century, with a large hat, a scarf and shiny shoes. She is perched on what looks like a shelf, but there's nothing else to tell us about her location. The large, dark hat seems to direct the focus to her bright eyes, and she gazes out at the viewer as if she wants us to take notice of her. All the interest is in the right-hand side of the scene.

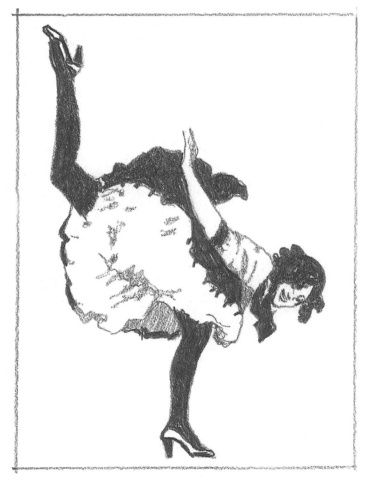

This last picture is a much more animated composition and would not be easy to draw if it had not been photographed first. The pose is fitted neatly into the frame with nothing else to be seen – there's no background and no clue as to where the woman might be. The drawing emphasizes that she is a dancer, whose main reason for being pictured is that she can use her body athletically. It's a very simple but difficult-to-draw composition, based solely on the figure's agility.

GROUPS OF FIGURES

When you're designing a composition involving more than one person, it's a good idea to find a group that is, for one reason or another, fairly static so you have plenty of time to make your drawing. The drawings on these pages are based on work by John Raynes showing musicians rehearsing. Although of course they were playing their instruments, sometimes with great vigour, they tended to stay in one place for a while and their movements were often repetitive. The lighting was very intense over the musicians and rather low elsewhere, so that the background was always very much darker than the figures. This helps to give a dramatic quality to them.

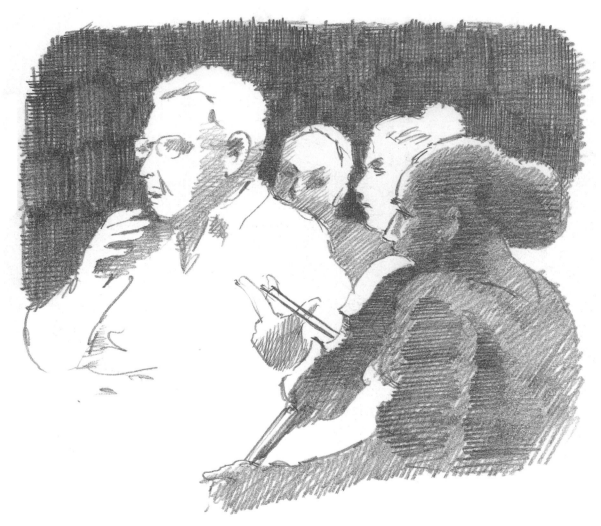

The first drawing is of just a few heads and shoulders with one figure, the conductor, very strongly lit, and a foreground figure with the light on her far side. The intensity of the shadows on her head and violin set off the light form of the conductor behind her.

Another couple of heads help to give a more complex look to the arrangement. The background tone is intensified because it throws the figures forward against the dark.

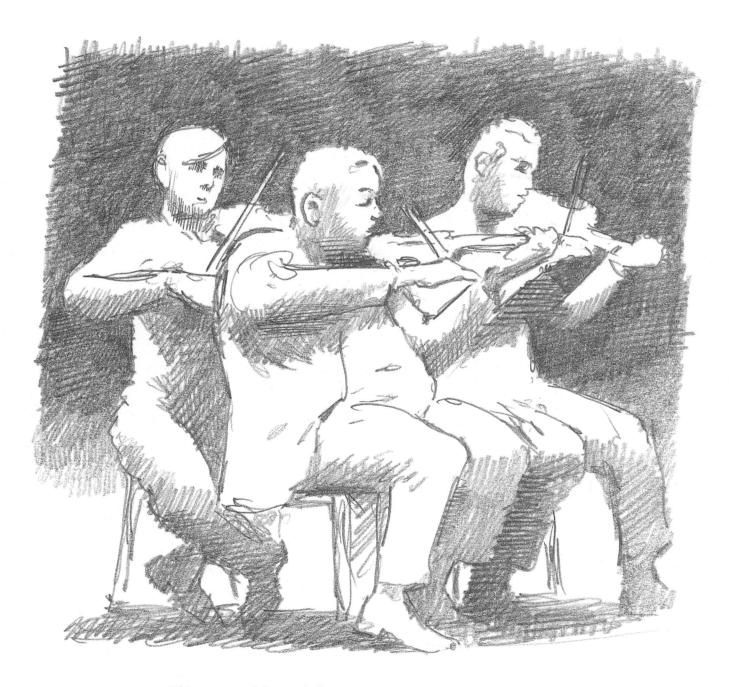

This group of three violinists is strongly lit from above, and they all stand out to the same degree. Once again the background was much darker than the figures.

The groups on this page are also based on drawings by John Raynes, and the first shows some elderly people sitting outside in the sun. The light is strong and everyone is lit from almost directly above. The areas immediately under the figures are in dark shadow, so the tones are strongly contrasted.

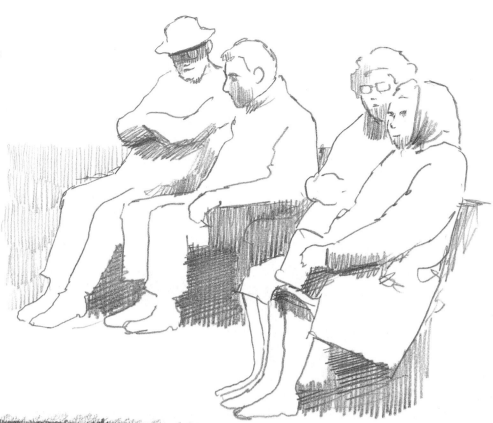

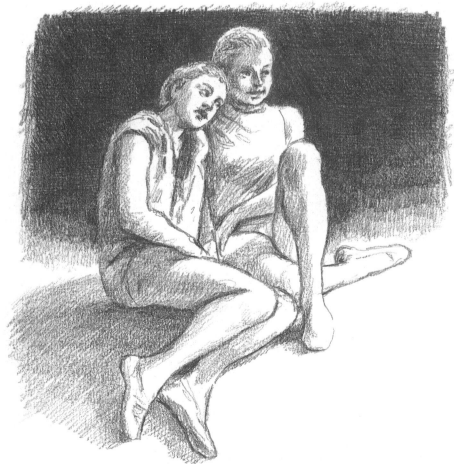

The two figures sitting on the floor are indoors and again the light is nearly all on them. Although the light is strong, only one side of the figures is brightly lit; their solidity is shown by the way the shadows define them. The background is darker but some of the shadows on the figures are also strong, and there is quite a range of tones to be seen.

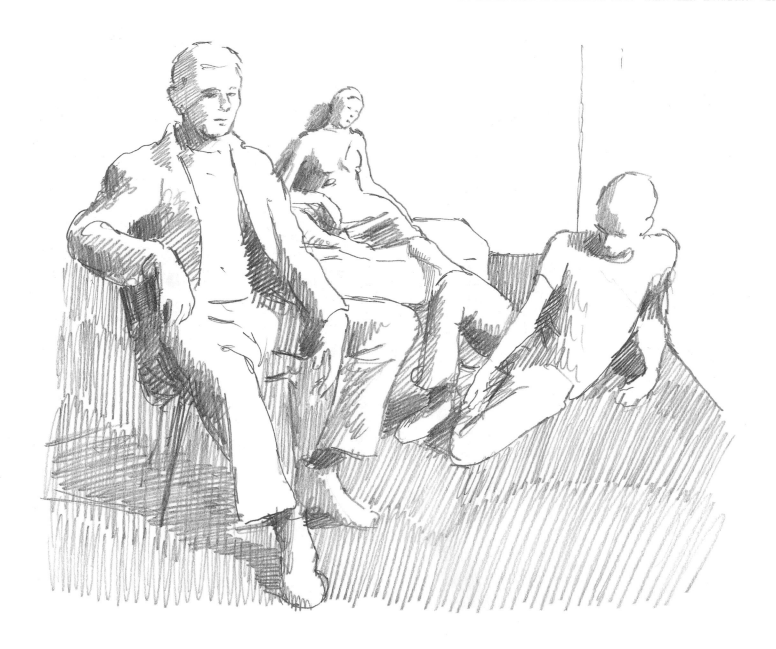

The last picture is of a group of figures, but each individual was drawn separately. This meant that I had to design the arrangement of figures to look as natural as possible. I've kept the floor in a darker tone to provide an anchor for the figures and all the light is coming from a window. Here the tone of the floor is part of the design, holding the figures together against a bright background. Notice how roughly the pencil marks are made, because when you're working out your ideas you don't have to get everything perfect. There's enough information to work out a more carefully drawn picture should I decide to take the composition further.

CHAPTER 7
USEFUL PRACTICES AND PROJECTS

In this chapter I have detailed some practices that are useful for any aspiring artist. They are very general and are here to encourage you to draw as often as possible, as well as helping to make the whole process easier. If there are ways of easing your efforts to draw well, you should take advantage of them.

● USING PHOTOGRAPHS

Although drawing outside is very good practice, when the weather is cold or wet it's not easy to do. At times like these it's useful to take photographs of the scene that you wish to draw and use these to work from. Take several shots from slightly different angles and also with different exposures to ensure that you get several versions of the scene; not only does it give you more information, it often helps to revive your memory of the occasion, which usually means that you get a better drawing. Print the photographs as near to the size of your drawing as possible.

When you're drawing a portrait of someone it's practical to photograph them before you start, so that if they get tired of posing before you have finished you still have the pose to refer to. You can also use the photographs to choose exactly which pose you want them to hold, trying out several shots before you decide which is the best one. When you look at the pictures on the camera, you'll be able to see which positions aren't successful in terms of lighting or composition. See overleaf (page 108) for more on portrait photography.

● KEEPING A SKETCHBOOK

If you want to be a serious artist, you should carry a small sketchbook with you as often as you can – a small one is easy to put in a pocket or bag, which means you'll be more likely to take it along with you. Use it as often as you can to draw anything that catches your fancy. As it's a sketchbook it doesn't matter if the drawings don't work brilliantly; the mere repetition of drawing things each day will enormously increase your skill. Drawing in a train carriage, especially on a long journey, gives you a range of models and I've found most people don't mind an artist sketching them – just don't make them feel awkward by staring too hard. You can often get quite good drawings done without anyone even knowing what you're doing.

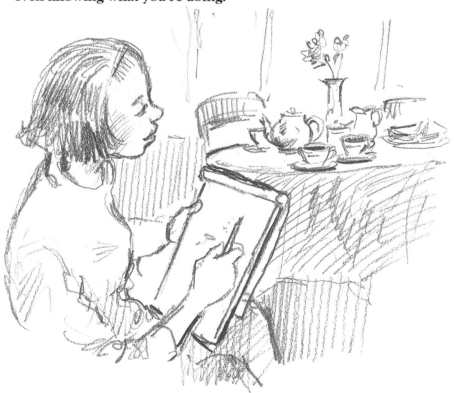

When you have moments of quiet by yourself you can draw the everyday objects around you in your sketchbook, trying to make your drawings more and more accurate. However, the sketchbook isn't meant to be filled with perfect drawings of major subjects – it's your notebook, to remind you of things that you might want to draw in more formal ways later.

● PORTRAIT HINTS

I like to use every means possible to help me to get a good likeness, and I often take a photograph of the model in the pose I've chosen so I can refer to it to correct the proportions in my drawing if necessary. To do this, take your photograph from exactly the same viewpoint you will use when you're drawing.

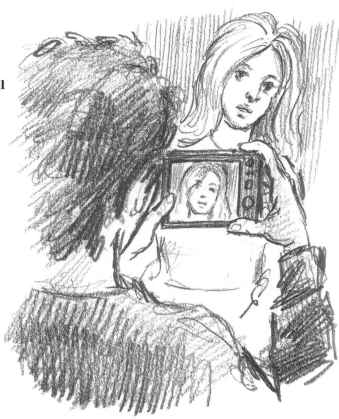

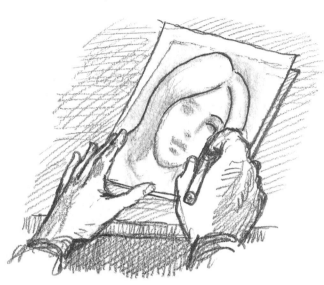

Make a print of your photograph as close to the size of your drawing as possible, then trace it so that you have a simple outline drawing to give you the right proportions of the head. Once you have the tracing, copy it on to your paper by placing the paper over the tracing on a window or a lightbox.

Now you have the correct proportions already mapped out, and sitting in front of your model you can continue to draw and get a much better likeness. If you think that this is cheating you're right – but all art is cheating, really, and artists have always used as many methods as possible to improve their drawings.

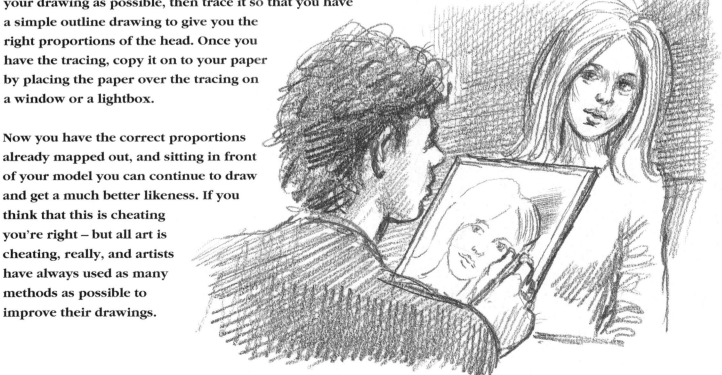

● COPYING PRACTICE

It's good practice to copy other artists' work in order to increase your technical skills – a traditional method of learning to draw well. If you want to know how Leonardo drew, for example, try copying one of his drawings from a print or a book and see how close you can get to reproducing it. Draw with your print as close to your own drawing as you can, because this increases your chances of being accurate.

Another time-honoured method to improve drawing skills is to place your print upside down next to your paper and carefully copy it in that position. What this helps you to do is to see that you are just drawing shapes rather than faces (or indeed objects), and once you begin to see just shapes and lines you'll find it easier to analyse what you are drawing.

● PROJECT: DRAWING ON THE MOVE

For this exercise I decided to walk into and round a room in my house and draw any view that caught my interest, just letting my impulses take over. This is a useful exercise because it takes a lot of the decision-making out of a scene and results in a variety of drawing problems for one to solve immediately, without any forethought. The exercise could just as well be more concise than I have shown here, drawing only one or two objects at a time.

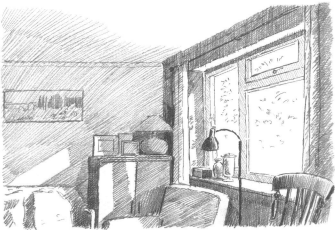

As I entered the room from the garden door I looked across to the far end and the corner of the window. On a small drawing pad, I began to draw what I could see, still standing up, and including whatever would fit into the shape and size of the page. I wasn't concerned about how much I could include, nor the composition – I simply drew the ceiling, cupboard, armchairs and so on as I could see them. The light shining through the window created strong shadows.

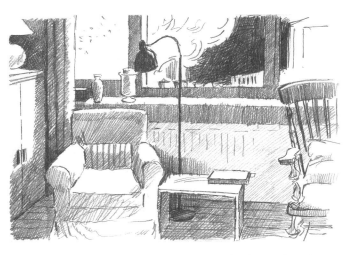

Then I turned and looked towards the window. Lowering my viewpoint a bit, I could see all of the armchair and the small table next to it, and the edge of the rocking chair to my right. Because I was now facing the light the shadows were darker. The objects were much the same as in the first drawing, but seen from a different angle and from slightly closer, so less of the room is visible.

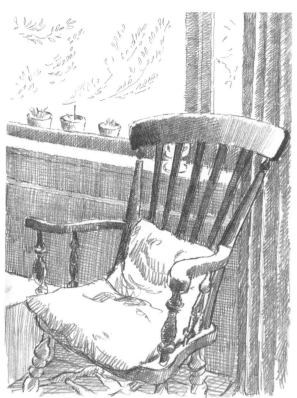

I now looked more closely at the rocking chair, which so far had been peripheral. It's sharply defined because most of it is dark against the background, and the highlighted parts are in strong contrast. The background is merely the windowsill and a curtain edge, so this picture is mainly about one object.

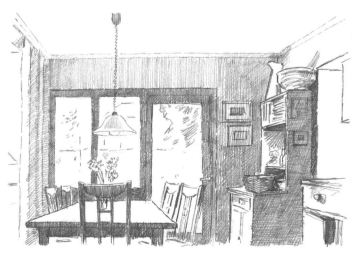

Next I turned round and faced the garden door that I had come in through. The window and door are dark frames for the light coming from the garden, and this reflects off the top of the dining table that is at that end of the room. To the right is a dresser with various objects on it, and some pictures on the wall. The chair backs frame the table top and the main light is positioned in the centre above it. Enough of the ceiling is visible to give an idea of the perspective of the view.

At this point I sat down so that I could get a slightly different view of the room. I looked up at another dresser, which is laden with cups, jugs and other paraphernalia, and because it's tall I turned my sketchbook around so that I could include the full height. This is quite a challenging view of the dresser from a low level, so I had to be careful with the perspective. I got most of the upper part in with a standing lamp at one side and a painting at the other. Because the dresser is so cluttered, I reduced all the objects on it to their simplest shapes. Again the shadows are quite strong to one side of the piece of furniture.

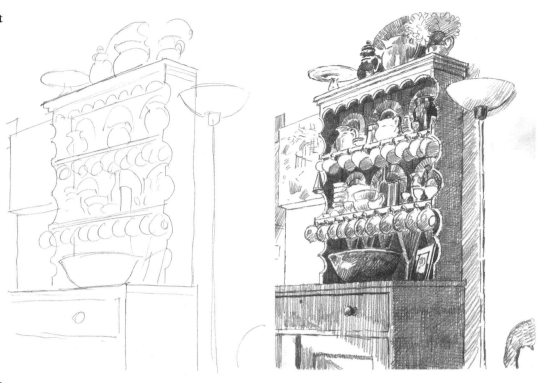

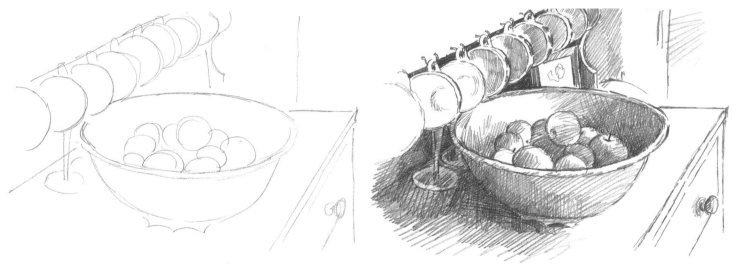

I stood up again and looked at the large earthenware bowl on the dresser, which had some apples in it. I drew this and included the row of cups hanging just above the bowl and a bit of the edge of the dresser. This is more like a simple still life drawing.

The last drawing that I made from this tour round a room is of another still-life detail. On the windowsill by the door a group of pears was ripening, caught in the shadow cast by the window frame. Because of the strong shadow, they largely melted into the background. So now I had gone around the room, drawing as I went and returning to the point where I had started, without thinking too much about what I should draw but just allowing my attention to wander to one thing and then another.

● PROJECT: CONCENTRATING ON ONE THING

For this test of your drawing practice, concentrate on one thing for a certain period of time – that is, you don't have to do all the drawing in one go, but spread it out over two or three days. Take a mundane object which has a little complexity about it, such as a shoe – familiar enough and very basic, but also quite a strange shape once you begin to study it.

First of all, draw the shoe from a side view. Notice the proportion of length to height and rough out your drawing in order to get this right. Then draw it with as much detail as you can, ignoring nothing about the texture and shape of it. Keep correcting as you go along and take the drawing as far as you can in the time available.

When the first drawing is complete, draw the shoe with the toe pointing towards you. Once again rough out the main shape, getting the proportions right. If there are shoelaces, tie them in a bow to keep them within the main shape. Once again, draw every detail, making corrections as you go. When your drawing is as good as you can get it, put it away until you are ready to draw again.

Now have another go at the shoe, this time with the heel towards you, and proceed just as you did before. This may seem a bit obsessive, but it's the easiest way to improve your drawing abilities.

Before you make the next drawing, compare the three you've already done as you'll spot what has worked well and what you should avoid repeating in the next drawing; this process also helps you to judge your own work more objectively. Now place the shoe so that you can look straight down into it. It doesn't matter whether you have the toe towards you or not – the main thing is to be able to see the whole shape of the shoe from above. Draw it as before, working towards the best result you can get.

Finally, draw the shoe with the sole towards you, which is quite challenging. It's the least obvious way to draw a shoe, so you'll have to be on the alert for unusual angles. When you're satisfied, spread the drawings out so that you can see them all together. You'll now know that you're capable of a body of work that exhausts all the possibilities of drawing a shoe. This is good for your artistic memory, because although you may not come to draw a shoe for some time, the memory will help you whenever you do have to draw one. All the drawing that you spend concentrated time on will help to inform your later work.

● TESTING YOURSELF

Keep testing your ability as you go along, and once you're drawing things that you seem to be getting along quite well with, strike out with something more difficult. Only you will know just what that is in your case, but let's look now at some objects that do have a certain challenge to them. It is necessary to draw the main shape of your object carefully, but don't worry about every tiny detail.

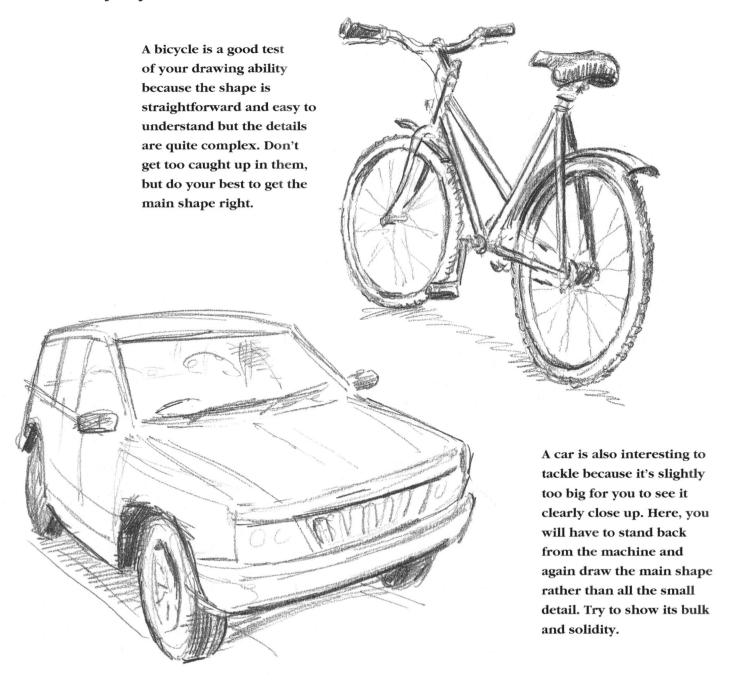

A bicycle is a good test of your drawing ability because the shape is straightforward and easy to understand but the details are quite complex. Don't get too caught up in them, but do your best to get the main shape right.

A car is also interesting to tackle because it's slightly too big for you to see it clearly close up. Here, you will have to stand back from the machine and again draw the main shape rather than all the small detail. Try to show its bulk and solidity.

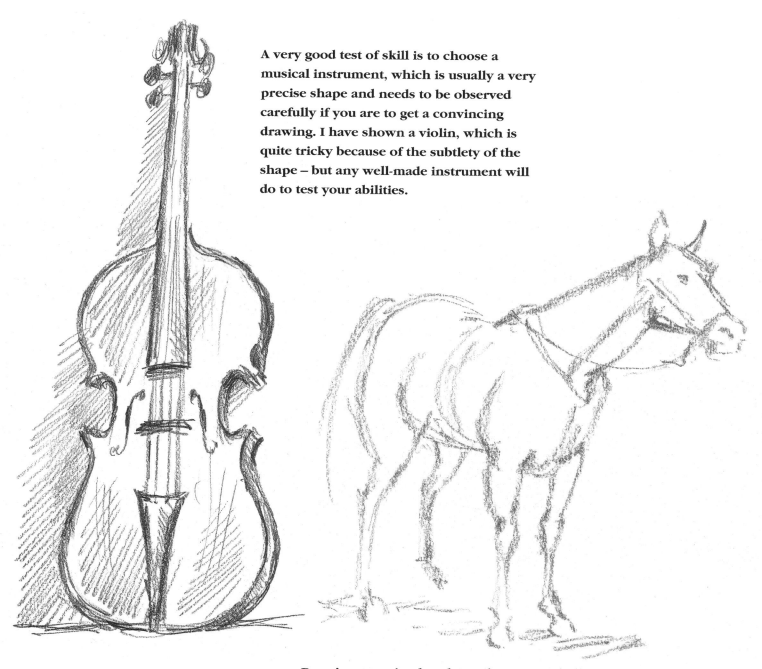

A very good test of skill is to choose a musical instrument, which is usually a very precise shape and needs to be observed carefully if you are to get a convincing drawing. I have shown a violin, which is quite tricky because of the subtlety of the shape – but any well-made instrument will do to test your abilities.

Drawing an animal such as a horse is a challenging subject, because it won't stand completely still. Sometimes you just have to draw as much as you can in the time that the animal is relatively motionless and then start a fresh drawing next time it stops for a while. This is useful in that it stops you worrying about how well you're doing; you just concentrate on getting anything down, and whatever you end up with, the action will enable you to practise looking and drawing without thinking about it.

● MEASURING A PORTRAIT

When you draw a portrait, measuring the head as accurately as you can before you start will help you to reach a successful result; you'll have the proportions clear in your head before you begin making marks.

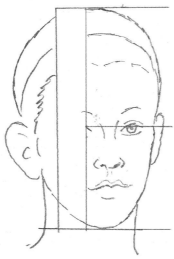

Using a ruler, first measure the length of the head and establish the position of the eyes.

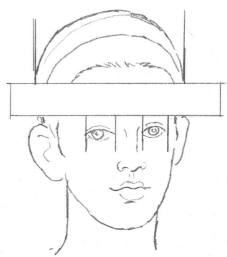

Measure the width at the widest point, which is just above the top of the ears, then measure the length of the eyes and the space between. Also measure the distance of the inner corner of the eye from the edge of the head, as you can see it.

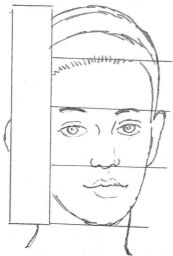

Next mark the distance from the top of the head to the hairline; from the hairline to the eyebrows; from the eyebrows to the end of the nose; and from the end of the nose to the bottom of the chin. As you go along, mark all these on your paper.

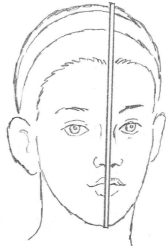

Then place your ruler in the centre of the face between the eyes and down the length of the nose, so that you can see what differences there are between the two sides of the face – nobody has one that is exactly symmetrical. This helps to get the character of the face more effectively.

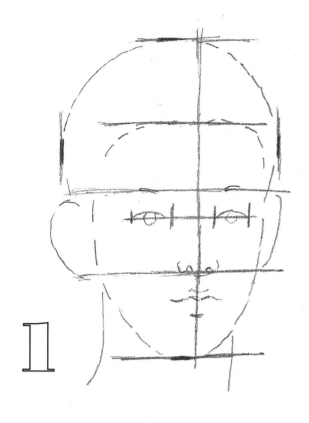

The drawing on the left (1) contains all the marks necessary to make a fairly accurate portrait, and it's now just a question of joining them up to make sense of them; you can go ahead with some conviction that you are getting the proportions correct. Put in all the tonal values when the shapes look right (steps 2 and 3).

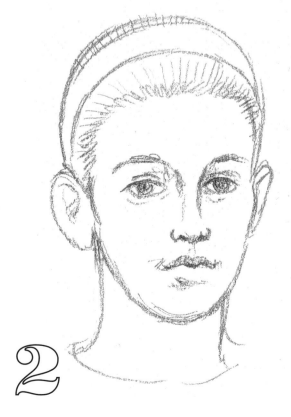

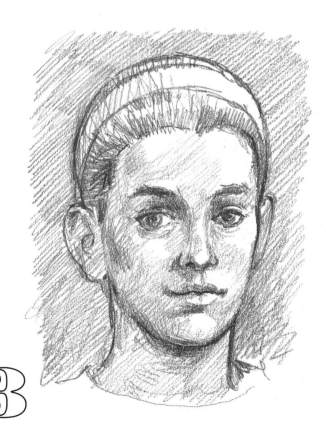

⬤ NEGATIVE SHAPES

In a drawing there are no spaces as such – the shapes between and around objects are just as important as the shapes of the objects themselves. These 'spaces between' are called negative shapes, and observing them will help you to draw more accurately and make more interesting compositions.

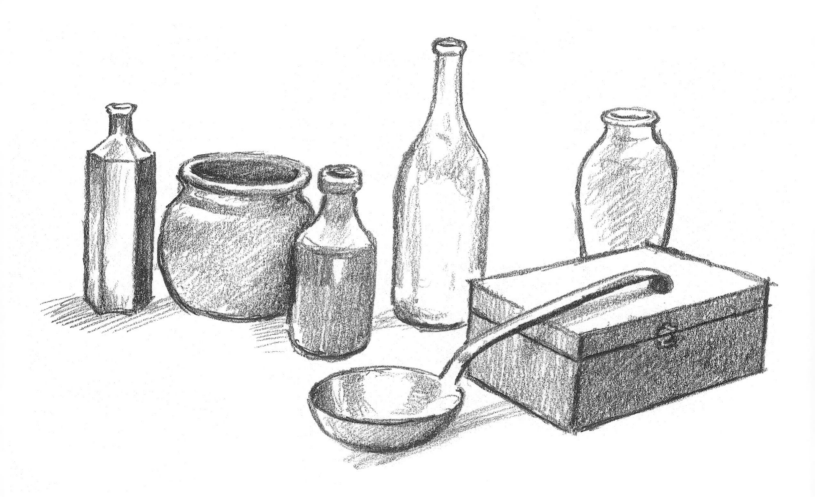

Here's a still life group, which you may want to draw. Your first instinct will probably be to try to draw it object by object, hoping that they will relate to each other correctly.

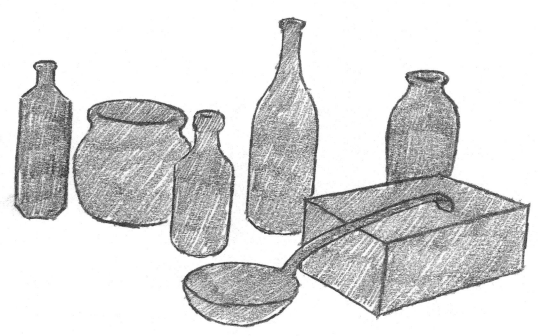

Seeing the group of objects drawn in a flat tone helps you to understand the main positive shapes and their relation to each other. This objective viewing is very useful.

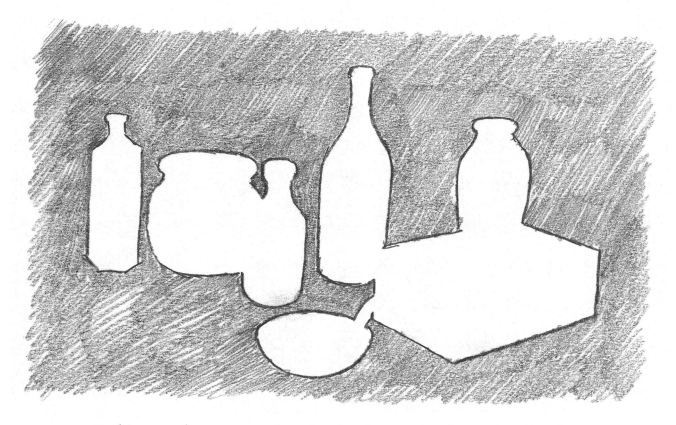

In this example you can see how drawing the negative shapes describes the forms of the objects and how much they overlap each other.

LANDSCAPE HINTS

When you're embarking on a landscape it can be daunting to see how much space there is and you may find it difficult to decide on which bit to draw. Artists often cut out part of the view by blocking off the edges with their hands, but a more effective way to do this is to have a couple of right-angled pieces of card and frame the scene that way. You can open or close up the gap in the middle as you require, and isolate the particular part of the scene that you wish to draw.

It's often difficult to find the right weather to draw outdoors for any length of time, so as we saw on page 106, using your photographic skills as an aid is a practical step. Here are some landscapes that I drew up for a set of paintings. I took two or three photographs of lakes in Richmond Park on the outskirts of London and as it was winter, and rather cold and wet, I was glad to be able to do this instead of sitting down with an easel and drawing from life.

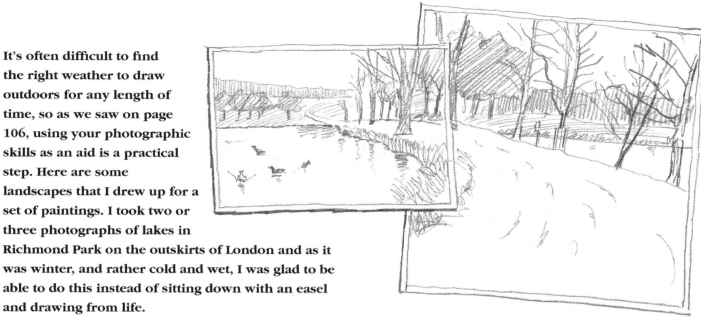

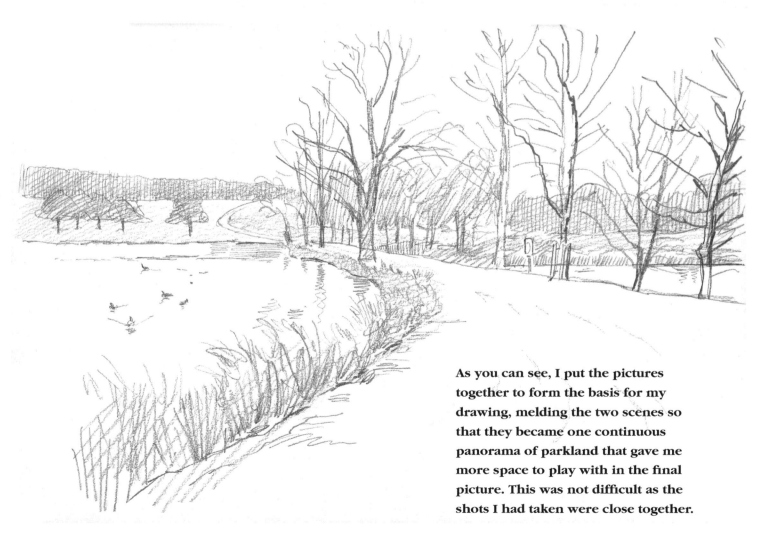

As you can see, I put the pictures together to form the basis for my drawing, melding the two scenes so that they became one continuous panorama of parkland that gave me more space to play with in the final picture. This was not difficult as the shots I had taken were close together.

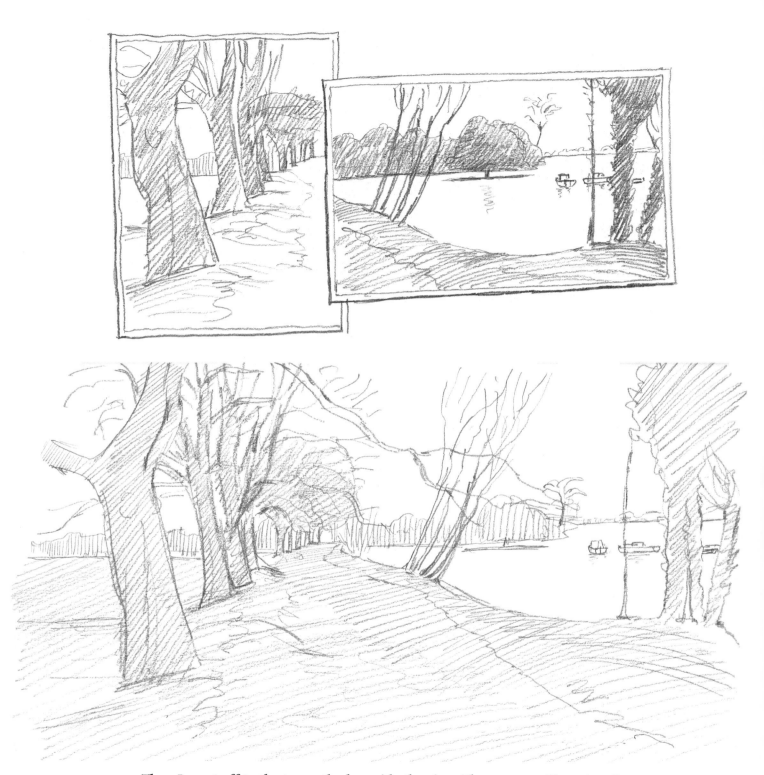

Then I went off to the towpath alongside the river Thames near Hampton Court and took two more photographs of the river and the bank close by. In order to get the two pictures to join together I had to draw a bit of the towpath from memory, but that wasn't a problem. The joining of the two pictures made quite a strong composition.

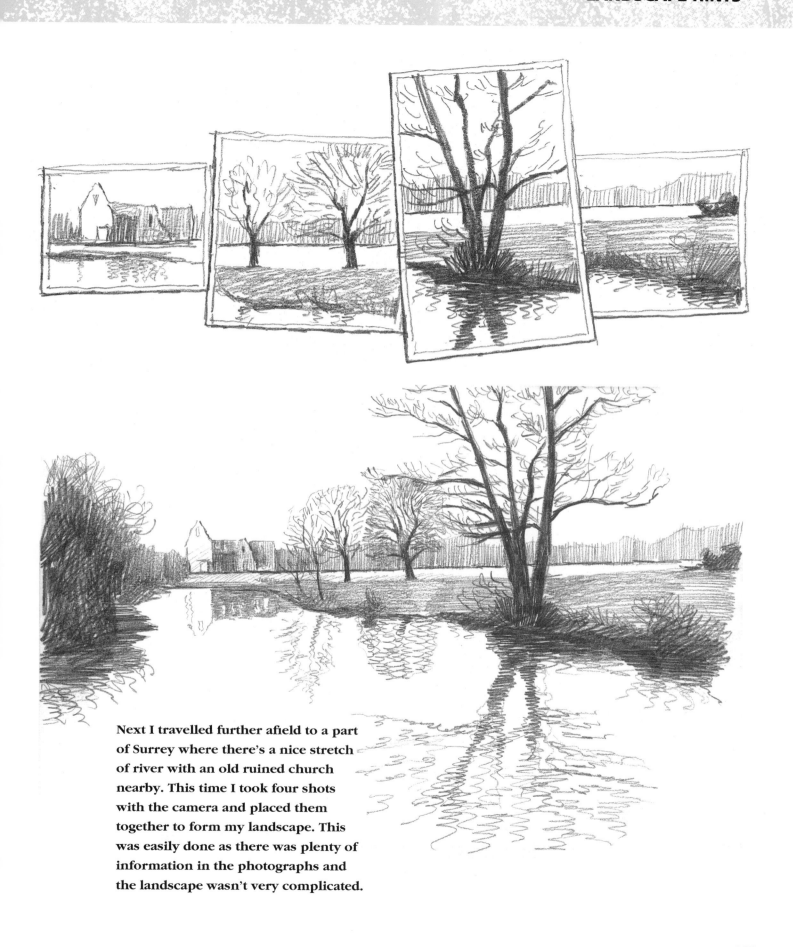

Next I travelled further afield to a part of Surrey where there's a nice stretch of river with an old ruined church nearby. This time I took four shots with the camera and placed them together to form my landscape. This was easily done as there was plenty of information in the photographs and the landscape wasn't very complicated.

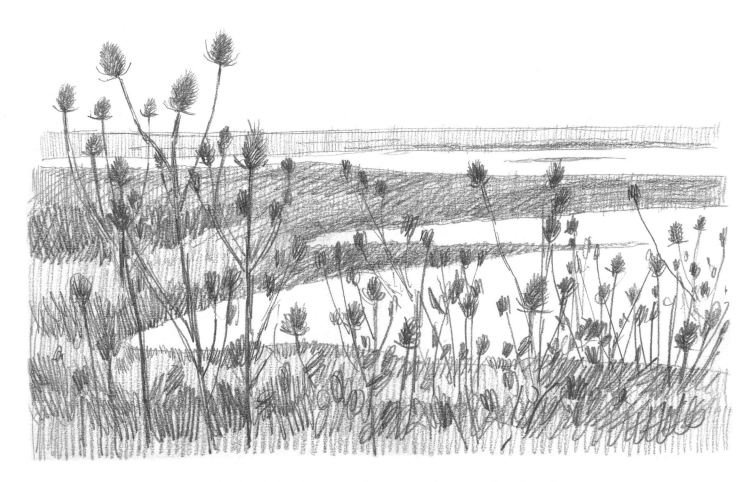

The final drawing came from one photograph only, of a wildlife sanctuary on the south coast, where I found a vast growth of teasels along the edge of a path, with a pebble beach landscape in the background. So as you can see, if the situation isn't very good for outdoor drawing you can always use your own photographs as sketchbook information and then draw the final result in the comfort of your home.

GOING TO GALLERIES

When you wish to inspire yourself by looking at the work of other artists, the best plan is to visit a gallery in which there is an abundance of pictures. However, it can be difficult to decide which to study closely, and looking at every one of them is not only tiring, it may result in you going home with no particular picture clearly in your head.

So, when you go into a gallery, just look around without any particular desire to pick out a picture and see what catches your attention. It might be a large work or a small one, it might be one with strong colour or dramatic composition – just allow your eyes to travel around until something looks interesting. Then go up to it and give it a few minutes of your attention, trying to clarify in your own mind what it is that you found attractive. This way of picking out a piece of work to look at can lead you to some interesting discoveries.

When you're looking at any picture seriously you have to allow a bit of time for it to sink into your consciousness, so look at it for at least a few minutes before you move on to something else. In order to absorb the quality of the work, note the composition, the way the colour is used, the tonal values and so on. You will find that you start to see much more in the picture than merely the subject, which is the most obvious thing. Soon you'll discover that some pictures really catch your imagination, while others have less impact. Yet it might be quite different next time, so don't expect always to be attracted by the same things – there is a vast world of art for you to explore.